Life of Work

WHAT OFFICE DESIGN CAN LEARN FROM THE WORLD AROUND US

JEREMY MYERSON
IMOGEN PRIVETT

black dog
publishing
london uk

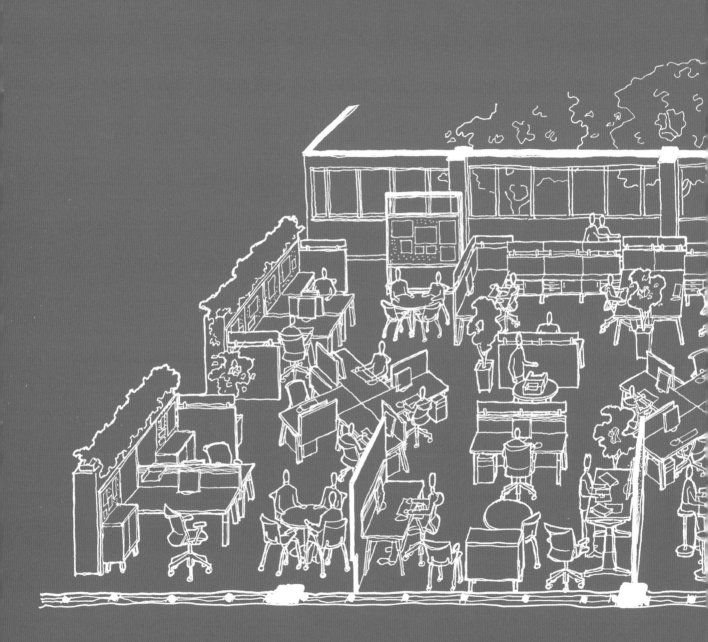

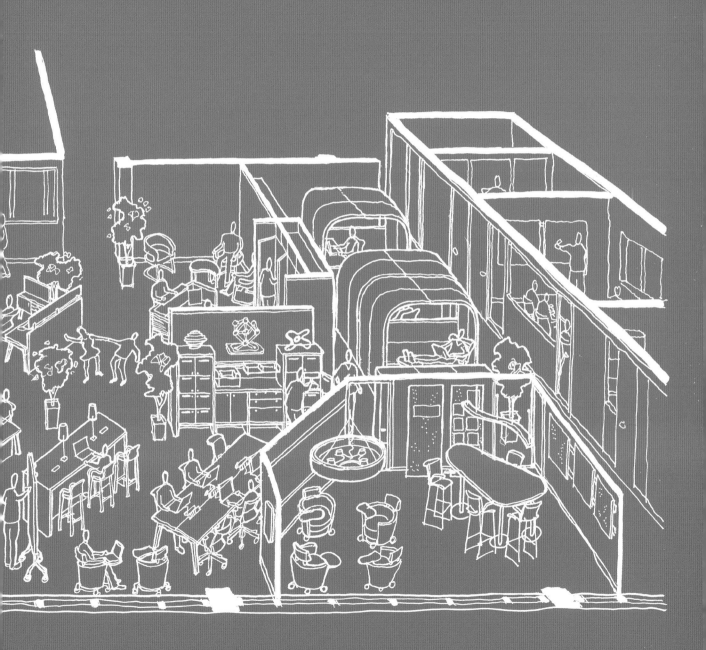

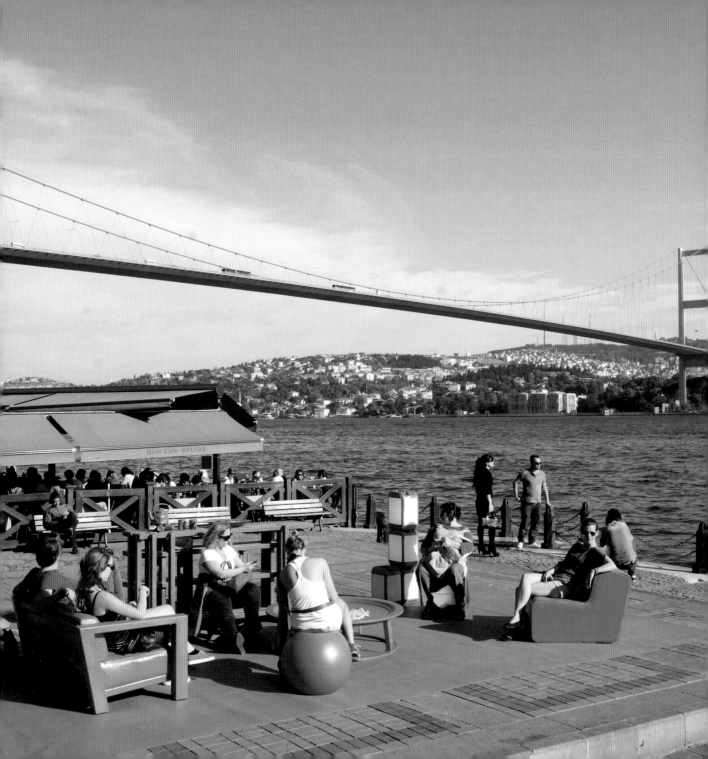

Foreword

The Roman architect Vitruvius described good design as a combination of 'firmness, commodity and delight' and it remains a definition that has never been bettered. The words of Vitruvius may belong to the ancient past but they have special resonance today in the context of workplace design, which we believe provides rather too much 'firmness' and 'commodity' and not nearly enough 'delight'.

This book describes how the office can transcend its utilitarian roots as an adjunct of the manufacturing age to provide people-centred work environments that engage and inspire rather than frustrate and enrage. It sets out a template for the future of the workplace by adopting a series of novel perspectives on how office design can learn from other spaces and settings in the world around us.

Life of Work is based on a major research project carried out by the Helen Hamlyn Centre for Design at the Royal College of Art. It takes lessons from the knowledge interactions of the academic library, the emotional landscapes of theatre design, flexible temporary events in the urban public realm and intensive team environments in air traffic control, media newsrooms and emergency medical departments.

The book views working life as a combination of *process* and *experience* — what we do, and how we feel. By exploring analogous environments, it builds up a whole new picture of the workplace encompassing not only physical settings that support work processes, but also people's psychological experiences within those spaces.

In creating this book, our two industry partners, Haworth and Philips Lighting, have given invaluable advice and support for which we are very grateful. We also want to give special thanks to Catherine Greene, senior research associate in the Helen Hamlyn Centre for Design, who led the first pilot study on academic libraries and who contributed enormously to our work.

Life of Work presents a framework for change that we hope will encourage everyone in workplace design to plot an escape from the tradition of mechanistic offices that are programmed for maximum efficiency without taking into account the human need for comfort and connection. If its recipe translates as more delight, then we are sure Vitruvius would approve.

Jeremy Myerson and Imogen Privett
London

Contents

Process and experience

What we need to learn

What we need to learn

It is one of the ironies of the early years of the twenty first century that working life is often so devoid of life. Why this should be the case when there is so much current investment in workplace design and so much debate about it is baffling. But there is now a mounting weight of evidence out there which suggests that things are not working as well as they should be — successive research studies around the world point to falling occupancy rates in office buildings and growing levels of dissatisfaction, disassociation, stress and sick leave among office workers. How we can improve the social and human dynamics of our work environments — and where we should look to find fresh answers to familiar problems — are the questions at the heart of this book.

The call sheet against the current status quo in workplace design is long and varied. Many office environments are still organised along the 'efficiency' lines of the industrial age and are simply not equipped to deal with the new, less predictable processes of the knowledge economy. Creating and sharing new knowledge is an essential and experiential requirement for organisations today, but too often choked off by factory floor-style workspaces and settings.

Managing a motivated, healthy and engaged workforce is another key requirement, but too many mechanistic workplaces are programmed to maximise efficiency without taking into account the human need for psychological comfort, connection and wellbeing. In this context, the pursuit of organisational productivity swiftly becomes counter-productive as individuals in all their complexity as human beings struggle to perform.

Groups fare even worse in the modern workplace. Static, inflexible work environments lacking group cues for use often stand in the way of genuine teamwork, impeding our ability to take collective action in an increasingly mobile and adaptable way. Generally, with a few bright exceptions to the rule, office users enjoy too little local control over their environment. Despite being social animals, they are afforded too few opportunities for social interaction.

Collectively, the individual charges on the call sheet add up to one inescapable accusation — that poorly considered office design inhibits the development of a positive and progressive organisational culture just as much as good office design supports it. If the design of the workplace blocks the creation and sharing of knowledge, or adversely affects the psychological comfort and emotional wellbeing of the workforce, or impedes genuine teamwork, or affords little by way of user choice and control, or stifles social interaction, or does all of those things, then the culture of the organisation and its ability to innovate and manage change is under threat.

In our investigation, we set out to find alternative approaches capable of making the twenty-first century workplace a better environment for people — more dynamic, more engaging, more colourful, more flexible and more inclusive. We looked for ideas and inspiration in some unlikely places and our journey over four years of research is documented in these pages. The more alternatives we examined, the more we became convinced that too much workplace design is fundamentally out of balance.

Lean workspaces derived from
manufacturing templates do not
support productivity or wellbeing;
people are not machines

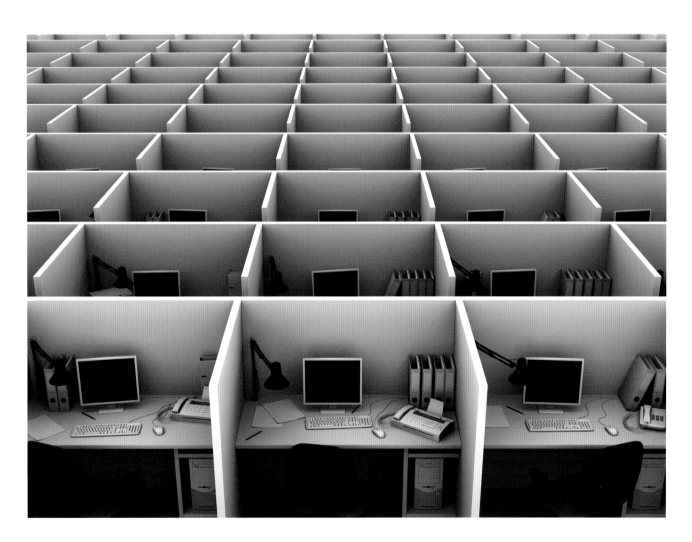

We came to a key way of thinking about the workplace as a combination of process and experience — what we do and how we feel.

Much workplace design tends to focus on one at the expense of the other. Some offices, for example, support working processes and practices efficiently but fail to create a positive, welcoming experience; others generate a great ambience or look visually arresting but are incoherent in terms of enabling work process. However these two aspects — what we do and how we feel — need to mirror each other if we are to create a more effective, supportive and productive workplace.

The need for change

Extensive studies of ergonomics and environmental conditions have given us a pretty good understanding of the basic physical requirements that are most conducive to work. Many of these are enforced by rigorous design standards. But although the primary function of the workplace is to provide a practical and functional space that supports people in performing their jobs, it is not merely a passive backdrop for work. We spend a significant portion of our lives at work — the level of interaction between people and the office environment demands more than just an adherence to health and safety rules. People need to be more than healthy and safe in the buildings they occupy; there is an emotional and psychological dimension too.

The recognition that work is a combination of process and experience — each with needs that must be met — requires new models for evaluating how our workplaces perform. Up until quite recently, most of what has been known about the employee's psychology in the workplace has concerned job satisfaction, largely evaluated by assessing individual 'likes' and 'dislikes'. In this context, it is perhaps unsurprising that a concern for economic productivity has discouraged companies from seeing any particular advantage in investing in workplace design simply in order to make people feel happier.

As a result workplace design has tended to only think about the effects of the environment when it actively demotivates people. This is not an helpful state of affairs — the extensive data now available on rising stress levels worldwide and on working days lost through ill health point to an urgent need to develop an alternative approach in which the psychological wellbeing of employees is placed at the heart of any workplace design strategy.

Two key researchers

In our review of the literature on workplace design, two researchers in particular helped to shape our thinking: Jacqueline Vischer and Craig Knight. Vischer is a French-Canadian environmental psychologist whose environmental comfort model (2008) addresses the limitations of simply measuring user satisfaction by making a helpful distinction between three different levels of comfort that people require in the workplace: physical comfort, functional comfort and psychological comfort. In Vischer's view, employers can only hope to maximise organisational productivity if the third level of psychological comfort is addressed. This is currently a missing link in workspace design, which tends to operate mainly at the levels of physical and functional comfort.

While Vischer was important to us for her interrogation of the meaning of comfort, British psychologist Craig Knight — the second researcher to really influence our approach — was significant for his analysis of the legacy of 'lean' working in his doctoral research (2010). A 'lean' approach to workplace design deliberately echoes the concept of lean manufacturing and is a direct legacy of an obsession with order that dates back one hundred years to the era of Frederick Taylor, the American engineer who pioneered time and motion studies. As WH Leffingwell, Founder of the National Office Management Association, wrote in 1919: 'Clerks in a disorderly office tend to become as their surroundings.'

Jacqueline Vischer's comfort model (2008)

This model describes three levels of comfort in the workplace: physical, functional and psychological comfort. Physical comfort is the most basic level and relates to providing an environment that is habitable — in other words, a workplace that has sufficient light and air, is safe to occupy and is not ear-splittingly noisy, freezing cold or insufferably hot. In an age of expanding health and safety legislation, relatively few modern buildings now fail to meet this basic habitability threshold. When there is a physical comfort problem — such as when washrooms or air conditioning units are out of order — this tends to have a negative effect on people's judgment of all other workspace features.

The concept of functional comfort links basic environmental necessities to the requirements of the work that people are doing. This is about viewing the physical environment as a tool for getting work done (independent from individual user preferences). Here, the difference between a supportive and an unsupportive

environment is the degree to which people can focus their energy on the task at hand, rather than having to expend it on managing adverse working conditions, whether these take the form of lighting glare, insufficient acoustic separation, or poorly thought out ergonomics.

As the range of tasks that is performed in offices becomes more wide ranging and complex, the concept of functional comfort becomes more important, with workspaces being required to facilitate a wider range of tasks without becoming too costly to build. Most contemporary workplace design stops at this second level of functional comfort. However, there is a third, generally under-developed level — psychological comfort — right at the top of the pyramid of user need. This links the psychosocial needs of the worker with the environmental design and management of workspace through factors such as territoriality, privacy and control over the environment (including the ability to physically adjust furniture and lighting). Psychological comfort also relates to individual feelings of attachment and belonging.

Comfort model of user effectiveness and wellbeing

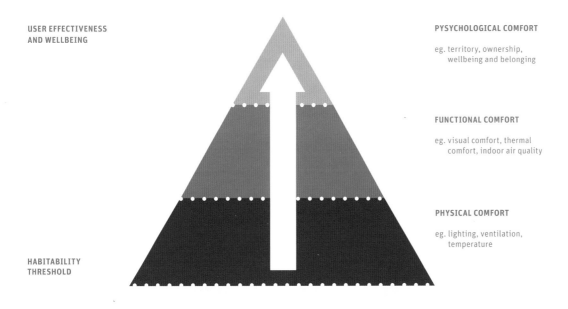

USER EFFECTIVENESS
AND WELLBEING

HABITABILITY
THRESHOLD

PYSCHOLOGICAL COMFORT

eg. territory, ownership,
wellbeing and belonging

FUNCTIONAL COMFORT

eg. visual comfort, thermal
comfort, indoor air quality

PHYSICAL COMFORT

eg. lighting, ventilation,
temperature

Craig Knight's PhD research (2010)

British psychologist Craig Knight carried out a series of studies to test productivity and wellbeing in different environmental conditions as part of his PhD research under the supervision of Professor Alex Haslam (Knight and Haslam, 2010). The first stage involved using questionnaires to ask more than a thousand office workers about their working lives. The questions related to the physical aspects of the participants' workspace, examined their sense of identification with their employers and explored their job satisfaction. The results showed that, where employees felt that they had control over their workspace and were working in a pleasant environment, they reported a greater sense of psychological comfort. This was then associated with greater identification with the organisation and enhanced job satisfaction.

The next step was a series of experiments designed to test whether these early findings had any measurable impact on business outcomes, with an emphasis on productivity. These experiments started from the premise that lean space management offered the best outcomes for business. Participants were randomly assigned to one of four different workplace conditions and asked to complete a series of tasks designed to test speed, comprehension and accuracy in processing and managing information. All of the conditions were in an enclosed single person office with a single window.

The variations in each condition were: lean (the office space comprising nothing other than office furniture, a pencil and paper); enriched (the office space decorated by a designer using a selection of plants and corporate art); empowered (the office space decorated by the research participant, who was allowed to choose and position up to six plants and six pictures from a selection provided by a designer); and disempowered (the participant was allowed to decorate the space as in the 'empowered' condition, but the design was then rearranged by 'management' — in this case, the experimenter).

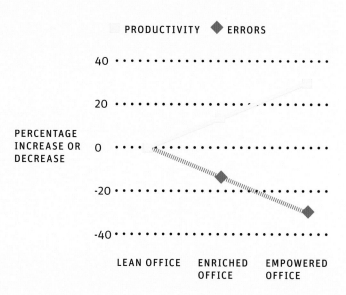

The result of the experiments indicated that simply enriching a lean space with pictures and plants saw both wellbeing and productivity measures rise significantly — crucially, without any more errors. Allowing people to develop their own space saw wellbeing rise still further and productivity increase by up to 32 per cent. Disempowering workers — the condition in which the 'manager' rearranged the space — had the effect of significantly compromising both wellbeing and productivity.

Above: Dr Craig Knight's study found that productivity rises and errors fall when people are given more input into arranging their environment

Right: Participants were asked to work under four different conditions with varying degrees of visual enrichment and control

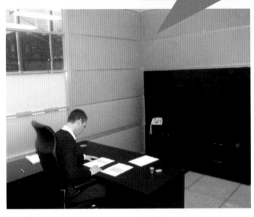

LEAN

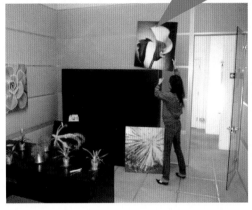

ENRICHED

EMPOWERED

DISEMPOWERED

The 'lean' model supports the idea that people work more productively in a 'lean' environment — such spaces can be characterised as being uniform, clean and depersonalised, with a focus on minimising distraction, standardising working methods and maintaining strict control over the working environment. A 'clean-desk' policy allows people to have out only those things that they need for the task at hand.

This assumed link between superficial order and improved productivity has historically led workplace managers to 'engineer' office environments along 'lean' lines for maximum efficiency in a deliberate homage to Taylor's methods. But Knight's research casts doubt on this link, suggesting that the long-established rationale for the 'lean' environment has no basis in empirical evidence and that workplaces fall short when they do not provide the crucial top level of user comfort — psychological comfort.

In an echo of Vischer, Knight argues that, far from being a model of productive efficiency, a lean space in which employees have no control or visual enrichment is psychologically impoverished and 'the least productive use of the working environment'. Perhaps we should not be surprised; it has been known for some time that if animals are placed in an empty cage, they begin to exhibit stress behaviours. It seems that we can no longer continue in the belief that the human animal is somehow different in this respect.

How to measure experience?

In their different ways, the studies of Jacqueline Vischer and Craig Knight brought us to the same realisation — that our ability to carry out functional tasks in the office and our psychological and emotional experience within that space should be given equal weight in creating effective and productive workspaces. But while the practical benefits of supporting work process are clearly understood, the role of experience in terms of measurable gains for the employer has traditionally been more difficult to measure. This explains why so many workplaces are ergonomically 'correct' but lacking in atmosphere or even a basic welcome.

In recent years workplace research has evolved to take into account a much more complex range of user behaviours, and to focus on the relationship between the physical environment and relevant productivity factors for companies (such as job satisfaction, organisational commitment, absenteeism and staff retention). There have also been several well-publicised departures from the lean and mechanistic office model to create highly customised, narrative environments that promote the company's brand values at the other end of the spectrum.

However, while these 'narrative' offices are often impressive spaces to experience, they are expensive to build and difficult to replicate, because they use specialist techniques and bespoke materials. They are also inflexible over time, making spatial responses to cultural change within an organisation a costly and time-consuming business. Toyota, Reebok, Quiksilver and Sony Playstation are among the global brands that have experimented with a customised narrative approach.

While on the surface these workspaces appear to offer a much more engaging environment, they are essentially top down, very literal expressions of brand identity and lack any genuine attempt to engage at an experiential level with the daily needs of their occupants. Some post-occupancy evaluation studies

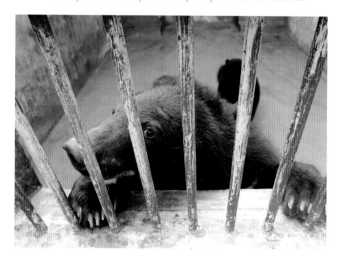

of these schemes have suggested that while they are initially positively received, the narrative joke quickly wears off for employees and any psychological comfort to be derived is lost.

The studies of Vischer and Knight point in a different direction. Their work identifies several key factors that contribute to our psychological experience within the workplace. These include allowing employees to make decisions about their own environment; developing clear territories to promote emotional bonding with place; and creating a sense of identity for the individual and for groups. These factors are heavily influenced by workplace design.

Knight and Haslam (2010) suggest that choice and control are powerful motivating tools for work, with productivity and wellbeing enhanced by including employees in decision-making processes. Vischer (2003) meanwhile states that empowering workers with regards to their work environment is an effective way to provide psychological comfort. At a basic level, environmental control might extend to being able to move furniture, adjust lighting and temperature, and control privacy levels; her evidence indicates a positive psychological impact from situations where employees are informed and even trained to make use of the controls available. This is a crucial point that is often missing from the redesign process; it is of little use providing adjustable environments if no one knows how to use them.

User control and productivity

Alongside Vischer and Knight, many other researchers have made the link between feelings of control and productivity. A 2010 study at Chung-Ang University in Seoul surveyed nearly 400 employees at Michigan companies and found a relationship between a perceived control by users over their work environments and their ability to focus. In this instance, 'control' was largely defined as being able to move furniture around within the workspace and customise displays. Survey responses indicated that when employees felt they had a say in the physical aspects of the work environment, the negative effects of noise and other distractions were reduced.

Far left: Zoo animals exhibit stress behaviours in empty cages; the human animal is no different

Above: The headquarters of Sony Playstation (top) and Toyota UK (below) are strong examples of a one-off narrative approach to workplace design

A PhD study by Justine Humphry (2011) found that the ability to personally shape the surrounding work environment was a key way for workers to prepare themselves for the day ahead; deprived of the opportunity to fix their local environment the way they wanted it, workers became dissatisfied and frustrated. The benefits of empowerment can be extended to the design process itself. Several studies have demonstrated that handing people control by means of user participation in the design process has a positive effect on people's response to and feelings about their workplace.

Armed with a wealth of background research that describes the key elements that might improve psychological comfort within the workplace — and determined to shift the debate from the narrow economic metrics of productivity to a wider survey of such behavioural issues as territoriality, belonging, identity, wellbeing and culture — we set about designing our own study with the aim of putting people back at the heart of the workplace. It seemed an obvious conclusion to us that when people are comfortable in their workspace, they are more engaged with both their surroundings and with the work that they do there. However the idea of 'comfort' having both a functional and an emotional component is a relatively new one, which is rarely addressed at a systematic level in the workplace.

About this book

Life of Work describes four interlinked one-year studies carried out between 2009 and 2014 with a period of reflection between the first pilot research project (on libraries) and the three successive studies. Our work set out to address a dislocation between process and experience within the modern workplace, exploring alternative solutions in analogous environments that link what we do and how we do it with how it makes us feel. We absorbed design lessons from academic libraries, theatre productions, temporary events in the city and intensive team settings to build up a picture of the new workplace as a total environment, encompassing the functionality of work processes alongside people's psychological experience within that space. The diagram on the right describes

how the four studies sit in a framework for investigation that covers individuals and groups, processes and experiences.

Our research started with a study of the individual processes of the knowledge worker, using the interactions of researchers with a new generation of radically redesigned academic libraries as the basis for thinking about how the future corporate knowledge workplace might evolve. This work, which proposes concepts for a range of settings that will enable people to work effectively at different stages within the overall knowledge generation cycle, is described in Chapter 2 – Knowledge interactions: Learning from the library.

Our second study extended our investigation to the individual's psychological experience within the workplace. We asked whether we could create office settings with a greater sense of mood, atmosphere and shared culture, but in an economical and manageable way without resort to expensive one-off fabrications. To do this, we looked at the language of theatre design, focusing on the pioneer modernist approach of 'minimal means for maximum effect'. Through archival research and the shadowing of theatre and workplace designers, we identified a new framework for understanding how we can bring a level of emotional richness into the workplace, supporting people's psychological needs while using a simple and accessible kit of parts approach. This work is described in Chapter 3 – Emotional landscapes: Learning from the theatre.

We then turned our attention to our shared experience within the workplace — the office is increasingly viewed as a social landscape — we asked how the flexibility and agility of temporary urban spaces such as pop ups, markets or festivals might inform the management of change and unpredictability. The popularity of these types of event lies in their ability to provide a rich, communal, spontaneous experience using adaptable, inexpensive and temporary components that are in sharp contrast to so many of our over-specified and static workplaces. This work is described in Chapter 4 – Flexible interventions: Learning from the urban realm.

INDIVIDUAL

STUDY 1
ACADEMIC LIBRARIES

STUDY 2
THEATRE DESIGNERS

PROCESS

EXPERIENCE

STUDY 3
TEMPORARY URBAN EVENTS

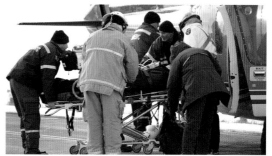

STUDY 4
EXTREME TEAMS

GROUP

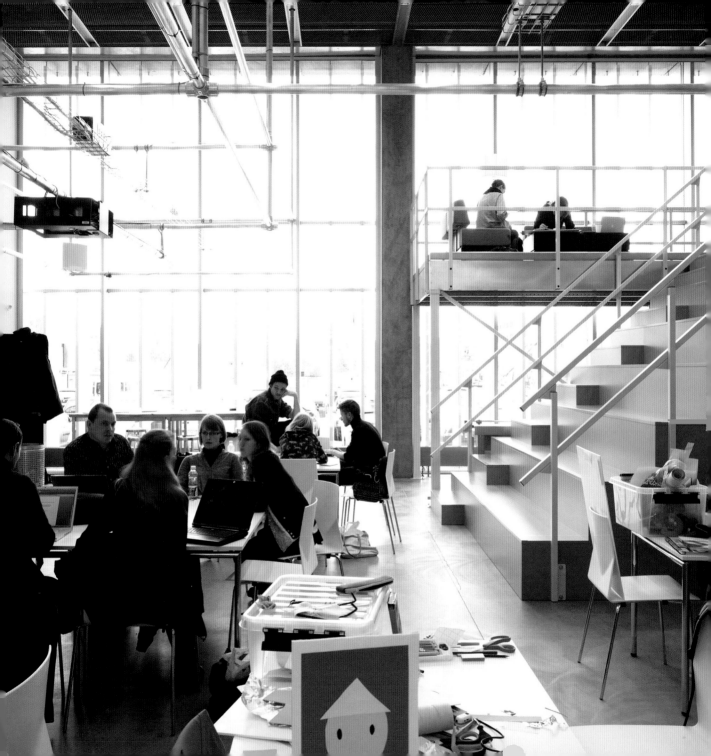

Our final study looked again at group dynamics but within the context of collective work processes. We chose to investigate working situations that depend to a critical extent on teamwork. The research investigates collaboration and communication within 'extreme teams' — high pressure, high performance teams working in air traffic control centres, accident and emergency departments and media news rooms. The study explores how processes and protocols are understood and communicated, how communication is managed and the degree to which the physical environment is a factor in supporting effective teamwork. This work is described in Chapter 5 – Extreme teamwork: Learning from the frontline.

Finally, we distilled all our findings from the many different environments we observed in our four studies to propose alternative ways to design for and with people in the future workplace. We consolidated our thinking in a model that is based around the core values of flexibility, legibility, quality of experience and comfort. We have called this approach the FLEX model and it is described in Chapter 6 – Framework for change: Learning a new language.

Life of Work deliberately confronts the flatness, uniformity and lack of dynamism and spark that so many offices around the world exhibit. People are not machines; to allow organisational cultures to flourish, we need workspaces that let individuals and groups do the work that they need to do and feel good about it at the same time. Fortunately, there are plenty of places and spaces in the world around us that give us fresh clues as to how we might go about building better environments for work.

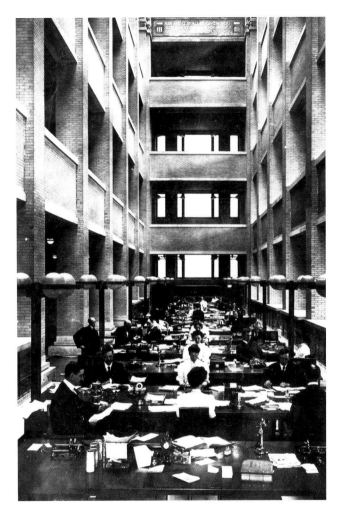

Left: Designlab by Rosan Bosch Studio is an innovative classroom at the IT University in Copenhagen and an excellent example of recent developments in the academic library

Above: Frank Lloyd Wright's Larkin Building (1904) is an architectural icon of scientific management. But is a culture of supervisory control really appropriate for working life in the twenty-first century?

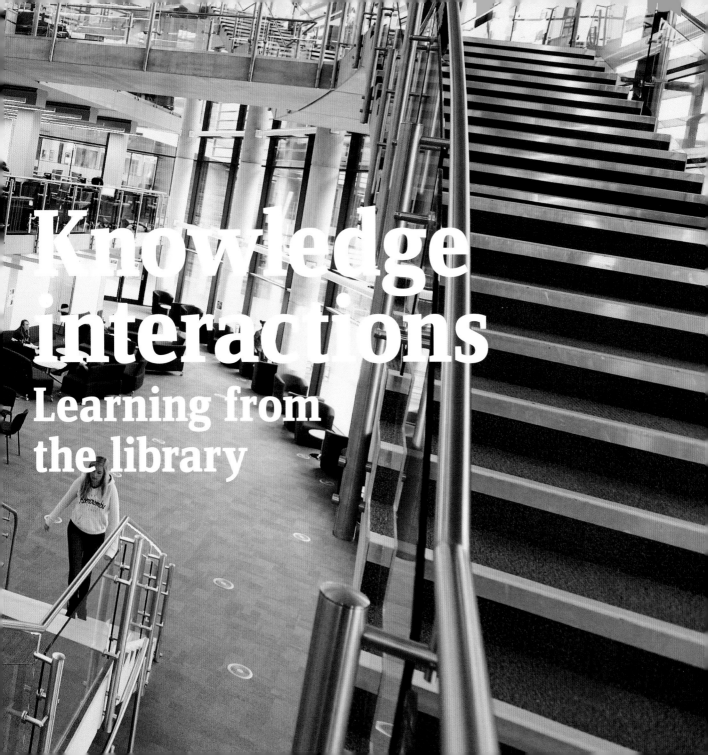

Knowledge interactions

Learning from the library

Learning from the library

We would not equip Formula 1 racing drivers with a saddle and a whip because the world has changed. Yet we persist in equipping knowledge workers in some of our most inventive and productive companies with a cubicle and a swivel chair. The world of work has changed — from an industrial economy built on command and control to a knowledge-based economy promoting creativity and ideas. Not that you would know it from the myriad offices all over the world that still force knowledge workers into the straitjacket of scientific management. Employees tasked with thinking up the next big thing must do so sitting in serried lines of desks that have been designed with a culture of supervisory mistrust in mind.

Half a century ago much office work was based on repeating processes being carried out accurately by the individual. Today that type of work has largely been automated. In its place is a type of work that is more experiential and less predictable — a type of work that is based on applying theoretical knowledge and learning fast in a culture of collaboration, exploration, autonomy and initiative. This is the world of knowledge work. In contrast to the repetitive and solo nature of more traditional process work, knowledge work changes all the time. Indeed, a finite knowledge set is now less important than the ability to adapt and learn, usually in participation with others. As the American economist Peter Drucker (2001), one of the founding fathers of the knowledge society, observed, "Schooling traditionally stopped when work began. In the knowledge society it never stops."

Technology has been hugely implicit in this transformation. Information is more widely disseminated than ever before and an increasingly global economy means that companies today need to compete internationally. In order to stay competitive on this global scale, organisations now recognise the need to continuously develop the skills of their staff. However this commitment is at odds with the workspaces in which most workers spend their day — these are environments still based on the template of the industrial factory floor, designed to restrict rather than to nurture independent thought. Unsurprisingly, many companies are struggling to adapt and, whilst there have been numerous experiments with creating environments that will support knowledge work, there are still no conclusions as to what really works. "Fad, fashion and faith drive most new work environments for knowledge workers," according to the American management theorist Thomas Davenport who has studied the field closely.

If frequent and expensive office redesigns for knowledge workers are unable to generate the insights required to catalyse a quantum leap in workspace thinking, then what could we learn from looking outside the corporate workplace? Was there a proxy for the knowledge workplace out there, similarly disrupted by digital technology and reshaping the way people learn and use information? Where could we look to discover new evidence on how to manage individual processes in the knowledge-based economy? We decided that the answer to these questions might be found in a building type that has seen transformational investment and innovation in the early years of the twenty-first century — the academic library.

The New York Public Library, widely considered as one of the ultimate icons of scholastic achievement. The world of academic knowledge work is embodied here in physical form

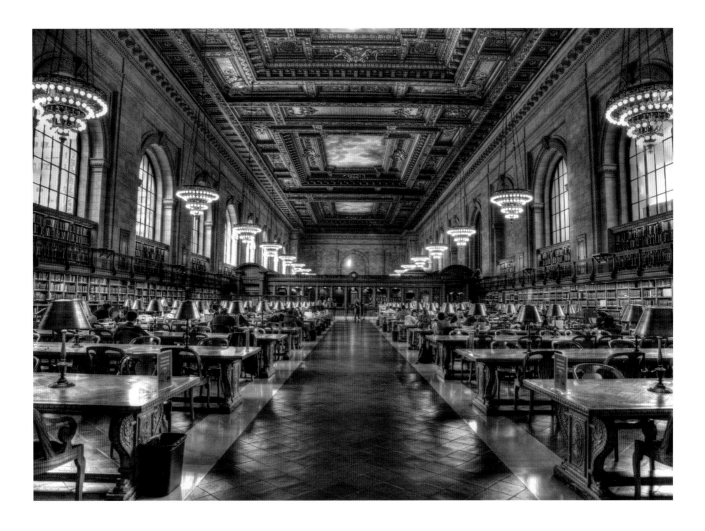

Left: New academic libraries such as the Warwick Learning Grid are constantly experimenting with new settings and technologies

Right: Imperial College Library provides a range of innovative settings that support different types of work

become more efficient in the space they use. Academic researchers have traditionally occupied cellular offices, but their patterns of work mean that these spaces are often occupied for only 30–40 per cent of the week, and there is growing pressure to improve space utilisation (Pinder et al, 2009).

Lessons from the library

On the face of it, the academic library could be described as the ultimate knowledge workplace. It provides settings for concentrated work, collaborative activity and social exchange. As Jamieson (2005) observed: "The range of activities that a university library needs to accommodate requires quiet zones where people can concentrate, interactive areas where they can work with one another utilising the latest technology, connections to online services and live experts, and space for social intercourse and community building." This led us to ask if the reinvention of the academic library could hold clues for developing new knowledge workspaces for the working world at large.

When we delved into the subject, we discovered that changes in the academic library have been driven by much the same factors that are affecting the workplace: increasing pressure on physical resources, widespread use of digital technology, and the resultant changes in the way that we work and interact. In the face of extensive budget cuts, universities in the UK and elsewhere are under pressure to

Space-saving models — such as open plan working — have been adopted in academia, but these have often been met with considerable hostility. Many academics have turned to working from home, only coming in for meetings and teaching appointments, with a detrimental effect on the collegiate atmosphere associated with a university. The parallels with falling occupancy rates in office buildings and a loss of corporate collegiality and community are inescapable.

Academic libraries are also at the centre of a debate about the value of physical space over digital space and vice versa. New technology allows knowledge to be accessed instantly from anywhere, releasing learning from the confines of a set building. This has prompted some to question the value of having a physical building at all, particularly given that 80 per cent of academic researchers are now accessing digital libraries from remote locations (RIN, 2007). However the fact remains that when we access digital content, we are located in a physical space and this environment impacts the way we work.

Above: Durham University provides dedicated Skype booths that enable cross campus collaboration

At an early stage in our review of the academic library, we spoke to a researcher from Bradford University who said: "Research is more than a digital thing, it is a living, breathing thing, so the spaces where you talk, write, think about it are really important." Essentially, the value of a physical space lies in providing settings that are appropriate to the social and mental activities that take place there. Effective knowledge environments should therefore focus on the needs of the people who use the space, rather than on the technology they will access there.

A further vocational factor is driving change in academic libraries. This is a growing need to provide a education that is more relevant to the jobs market. To meet the demands of students – who expect more in return for paying higher tuition fees – universities are responding with a 'relevant academy', moving from a scholarship of discovery (knowledge for knowledge's sake) to a scholarship more applicable to the job market (Universities UK Report, 2007).

This has resulted in a much greater emphasis on social learning and teamwork. Recent statistics show that 38 per cent of academic researchers are working collaboratively (RIN: 2007).

To meet this change, university libraries have been forced to shift from their previous role as repositories of information to a new focus as service centre and workspace. Their new names illustrate the type of experimentation now taking place: the term 'library' is increasingly being replaced with more descriptive titles such as 'The Learning Grid', 'The Research Exchange' or 'The Why Factory'. Out of this experimentation is emerging a distinctly new typology of workplace where a variety of settings are being provided for different types of work, whether solo, collaborative or contemplative. This variety provides people with the ability to choose the setting most appropriate for the task in hand and it can be viewed as a testbed for future corporate knowledge workplaces.

A framework for research

In order to understand how the academic library might evolve to support knowledge workers in the future, we needed to understand how they work day to day. An initial literature review indicated that, despite widely differing fields of research, the basic journey is very similar. So we began by developing a generic framework for research projects. This circular process has five stages, moving from time spent getting information during the 'discover' and 'gather' phases (input focused) to actively using information during the 'analyse', 'create' and 'share' phases (output focused). This cycle exists in many forms and can span a day or a number of years, but was broadly recognised as generic by the researchers we contacted.

The framework allowed us to map where researchers are working, what they are using, and who they are working with for each part of the process. Traditionally, libraries focused on the 'getting' part of this process. Their service was designed around the assumption that a researcher arrived at the beginning of a project with a specific question, and the library was there to provide the resources to find that answer. Today, there are multiple points of entry and libraries must embrace the entire cycle of the research journey, welcoming researchers and providing them with the space and resources needed at every stage.

Imperial College London
Emrys Architects, 2008

The new library at Imperial College London (right) was specifically designed to facilitate new learning methods, with different zones that support different types of work. In the new IT learning suite, the majority of desks are individual, with subdued colours to encourage quiet, concentrated work. There are also private group rooms and larger teaching areas where staff members run lectures and seminars. There is a dedicated group study area that is designed to be flexible, using furniture that can be easily rearranged and a series of screens that break up the space but can be moved for a larger event. There is a popular central Learning Cafe, with lots of different sized tables, some with head-height screens mounted onto the wall. The scheme points to the value of creating a range of spaces and atmospheres that provide a balance between different modes of work.

The Jennie Lee Building @ The Open University
Swanke Hayden Connell, 2008

This library (left) was specifically designed for researchers, and they were involved throughout the design process. The researchers asked for quiet spaces for concentration, technology that was easy to use, storage space, potential for personalisation and places to read. These needs became part of the brief for the project. The space contains a number of labs for testing, meeting rooms and office space. It is designed around a central atrium that is used as a social space, with open plan kitchen areas and comfortable seating. Each section of the building is supplied with quiet rooms in response to calls by researchers for a place to read, to hold video conference calls and concentrate for relatively sustained periods of time.

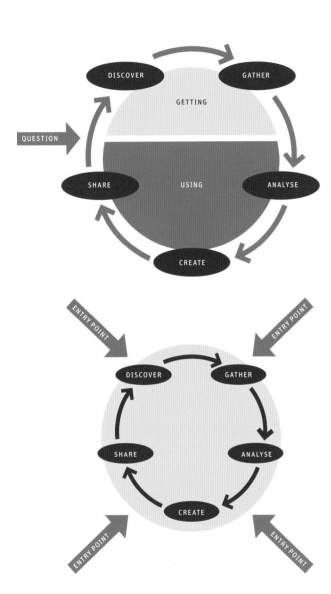

Above: Libraries traditionally focused on providing information for researchers. Now there are multiple points of entry and libraries must provide the resources and settings needed at every stage of the research journey

We used this generic research model to delve into the lives of 14 researchers — among them a physicist, historian, sociologist, law professor and economist — to ask them about the spaces they use and the tools they need throughout their research journey. To ensure a wide range of responses, researchers were chosen from both the academic and corporate worlds and along a spectrum from digital native (someone who has been using technology all their life) to a digital immigrant (someone who has had to learn to use technology in recent years). In-depth interviews were held with each person, aiming to map the spaces, tools, furniture and facilities that each researcher used during each stage of the process. We also asked about where they got their inspiration, what they did when they 'got stuck', and what part of the process relied most on a specific space. Finally, each researcher was asked to describe their ultimate research space.

Insights from the study

Mapping the time spent using the library onto the framework revealed very different working patterns. One researcher used the library as his main workspace; another only used libraries during the early stages of a project; a third barely used the library at all, preferring to work in other locations. Differing patterns could be partly attributed to whether the researcher had a suitable workspace at home, but they were also the result of people being very specific about the spaces where they felt that they could work most productively.

These spaces varied from person to person, and changed as they progressed through the project. For example, the sociologist preferred an informal, comfortable setting away from the library for online research during the 'discover' phase; the geographer sought out private individual workspaces during the 'create' phase; and it was important for the economist to be able to walk outside to gather his thoughts when in the 'analyse' phase. These examples reflected the general tendency to either move around or 'nest' depending on what they were doing; more than one researcher mentioned the benefits of variety to keep their mind fresh or get them out of a rut.

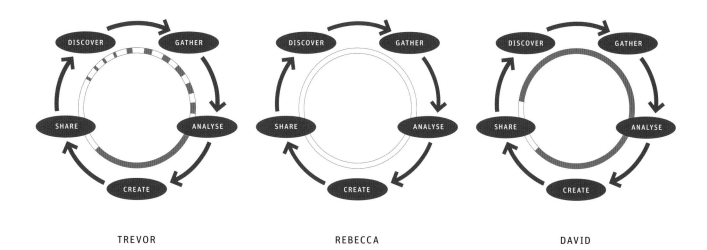

TREVOR

REBECCA

DAVID

We found that a tendency to seek out spaces with specific qualities during different phases of their work was common to all of the researchers, with varying requirements in terms of privacy, amount of space, levels of ambient noise and variety of settings. At the outset of a project — the 'discover' phase — most preferred a dynamic work environment which maximised opportunities for chance exchanges. Researchers tended to seek out relatively public spaces where the noise and buzz was felt to be productive and inspiring; in this phase they were often highly mobile, moving from one setting to another according to need and inclination.

Moving into the 'gather' phase, many of these requirements were the same, although the researchers also expressed a greater need for privacy and occasional opportunities for quiet contemplation. This requirement became much more pronounced during the 'analyse' and 'create' phases, when most researchers sought out private, quiet spaces where they would not be disturbed. They also placed a much higher value on the amount of space available

and tended to 'nest', leaving their research materials spread out for longer periods of time. As the project reached the dissemination phase, they moved back towards using much more open, public spaces that supported the sharing of information.

In an increasingly virtual world, place clearly remained important to people, and the library as a destination was important to several of the researchers we interviewed. They valued it as a social place and regarded having other people working around them as motivational. Some particularly valued being surrounded by people from different disciplines and walks of life, rather than always being sat with people engaged in the same kind of work.

SOCIOLOGIST **GEOGRAPHER** **ECONOMIST**

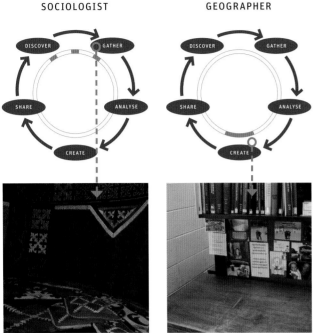

Left: When not in the library, researchers were highly specific about where they wanted to be for particular tasks

Right: The research revealed clear patterns in the characteristics of spaces used at each stage in the research journey, from open, vibrant areas to more private, contemplative settings

Physical information was also important, with many researchers lamenting the disappearance of bookshelves from the library; online research does not provide the same opportunities for serendipitous discovery afforded by the physical co-location of information. As one researcher told us: 'Digital research is too linear, you need to be able to bump into things along the way'.

The value of tangible things was also reflected in the analysis of information; people often felt more like they 'possessed' knowledge if they were able to physically lay it out to make sense of it all. Although all used digital tools, being able to physically manipulate information remained an important element in most of the researchers' working process. As one told us: "When it is on a wall you make connections between the things that are written up."

Many of the interviewees talked about the important connection between the 'share' and 'discover' phases; it is often during the dissemination for one project that new ideas arise for the next.

For many, the 'share' phase was the most socially interactive — they valued the collaboration that came about as a result of physical proximity — but current 'share' spaces were generally regarded by the researchers we spoke to as inadequate, uninspiring and inflexible.

Developing design concepts

Armed with our insights, we held an expert forum with a group of academics, architects and designers to discuss the relevance of the project findings to the wider knowledge workplace. Through a co-design process using the interview insights, precedent images and sketches, this group was able to identify several areas of opportunity for design in each phase of the research cycle. It is important to note that the knowledge settings that were generated are not exclusive of each other but designed to be used in combination, providing a range of spaces suitable for a broad spectrum of activities.

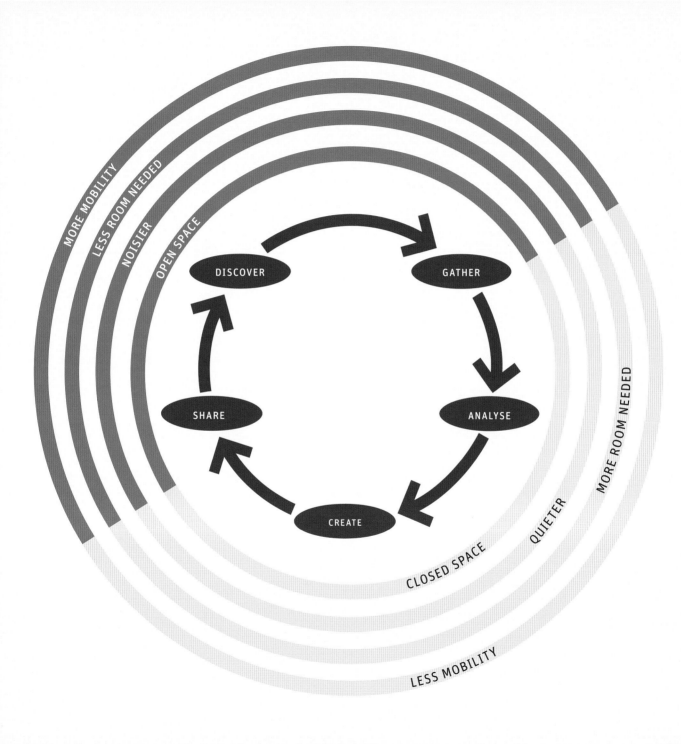

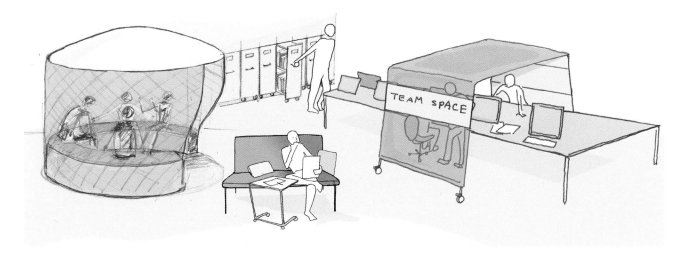

Concept sketches developed during
a co-design forum based on the
research findings

Discover

The 'discover' phase is generally the entry point to a project, and activities include reviewing, finding, developing questions, attending conferences and reading. Digital information has become the first port of call, and people undertake broad web searches before turning to on-line journals, catalogues and databases. However researchers also seek out information triggers that help to throw new light on their understanding of a subject, and will explore information presented in different media, with physical artefacts remaining an important part of the process. The importance of physical space in supporting serendipitous finds by physically co-locating information was highlighted by many of the interviewees. As a Doctor of Psychology at University College London told us: "Bumping into somebody, you have a conversation which generates an idea that is completely unexpected and original — you don't do that by e-mail."

Researchers will often move around during the day to work in a combination of settings. Immediacy is important — to be able to open a laptop and get to work quickly, and to feel comfortable and welcome wherever they are. The implication here is that workspaces need to be easy to configure with clear protocols of use. The importance of serendipitous discovery at this stage of the project also means that researchers tend to seek out environments that create opportunities for chance exchanges. Thus, 'discover' settings would benefit from being placed centrally and along circulation paths to and from other spaces. These spaces should be social, collegiate and dynamic, hosting events, showcasing new information and providing presentation space. To a degree, the discover phase permeates an entire project, and a new discovery during a later phase can bring fresh energy to a flagging concept.

DISCOVER
Media Swap

Media Swap combines a bookshelf with a touch-screen internet point, allowing both media to support rather than compete against each other. The researcher is then able to extend their exploration at the point where it is most useful. Media Swap also aids serendipitous exchanges between researchers, enabling them to swap references and share ideas.

DISCOVER
Alcove

Time spent at the university should maximise the potential for interaction with fellow colleagues and students. Alcove creates an opportunity for people to stop for meaningful exchange. Situated in an entrance hall or walkway, it is designed to be noncommittal and used for short periods only. The increased intimacy of the Alcove is more conducive to private conversation, and an integral writing surface allows people to use visual notes to support spoken explanations.

GATHER
Canopy

All settings need to be defined by a boundary to varying degrees. Canopy is a semi-transparent enclosure which provides increased intimacy without losing the connection to the wider space. Its mobility enables it to be used across different settings, with the space being formed and re-formed according to need.

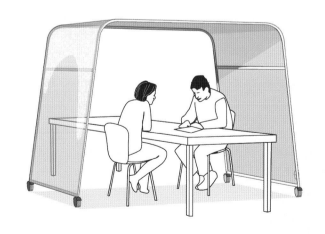

Gather

The 'gather' stage involves bench and field research, administration, conceptualising, reading and writing. At this stage, it is as if several empty boxes have been labelled and the researcher has the task of filling them with relevant information. As they collect this data, researchers will store it for future reference. Books are photocopied or scanned, and digital texts are downloaded in the form of a pdf. Physical storage remains an important factor, as many workers print their most important texts and store them physically for ease of reference through the research process. Insufficient storage in their workspace means that people resort to storing files at home which, in turn, means that they do most of their work there.

With the same need for openness and vibrancy, there is opportunity for overlap between the discover and gather spaces. However, researchers desire an increase in privacy during this phase, allowing quiet group work or private study to take place,

particularly where their research relies on input from other people. Increased boundaries and partitions allow for this sense of retreat, but should remain flexible so that they can be formed and re-formed depending on need. The researcher is most mobile at this stage of research, whether out searching for specific sources or doing field research, so inhabiting a space is less important than being able to dock down immediately. The interactive nature of this period of research requires good access to a variety of informal meeting spaces with the capacity to facilitate anything from Skype conferences to an informal brainstorm.

Analyse

In the 'analyse' phase, the researcher has gathered a volume of data that needs to be turned into useful information, so creating a platform to apply their own theories. This phase involves organising, annotating, interpreting, manipulating, brainstorming, discussing and making associations. The volume and complexity of data means that it needs to be visualised in a way that makes

ANALYSE
Analogue Island

"When I am stuck, I go walking". It is during the depths of the analytical phase that researchers often need a reflective space to escape to. The journey to this place is as therapeutic as the destination with researchers citing the benefits of walking in helping to sort out their thoughts. Analogue Island uses a combination of seating and natural landscaping to create both a journey and a destination. Placed within a space it creates an obstacle around which one has to walk; placed away from the space it acts as a destination one has to walk to. Analogue Island is an example of a contemplation space, as defined in the RCA's Welcoming Workplace study (2009).

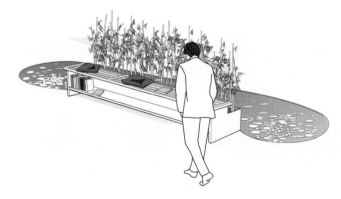

it easier to manage. Visualisations can be made digitally, and tools such as key word searching and data mining programmes are often employed. However, many researchers prefer a more physical approach and the ubiquitous Post-it note is a common visual aid. This ability to physically move and reconfigure data has been shown to enhance the process of analysis, as the physical action makes it easier to identify connections and themes (Beard & Price, 2010). As one Professor of the built environment told us: "I like to change the sequence in which information is presented by skipping back and forward through it."

With ideas forming but still fragile, concentration is critical. Space is significant in helping researchers give form to their ideas — interviewees spoke of the importance of being able to 'own' a quiet, private space for a period of time. This facility allows them to lay work out, leave it behind and then quickly pick up their train of thought the next day. The need to own space and display physical information means that the library — or the workplace in its current form — is rarely a choice location.

At the 'analyse' stage, the researcher has changed from an input to an output focus and the space should reflect this. In contrast to the earlier spaces, it needs to be clean and empty, encouraging the researcher to fill it with their own ideas. Space to walk around is also important — our participants spoke of the value of moving around in helping them to organise their thoughts and generate ideas. This is quite an introspective stage of work; to counteract this, there should be views out to other areas of activity or to the outside world.

Create

'Create' activities include reviewing, testing, developing, writing, visualising and formulating. At this stage, the researcher is actively using the information that they have collected to create their own work, and will be formulating their ideas with a view to dissemination. They have a constant need to refer back to their own library of resources and space to keep projects open remains an important factor. Some actively seek out new information, surrounding themselves with new sources that help them to interrogate their ideas and breathe new life into the work.

Space is most important during this phase and researchers seeking an escape often change their workplace. These choices are subjective — some need a vibrant open space where they find that the anonymous buzz of people passing creates a productive atmosphere to work; others require the opposite and escape to quiet corners where they will not be disturbed. Personalisation is also important, and is linked to this tendency to seek out new spaces. People know how they work best, and want to be able to adapt the space to their needs, whether this is to change lighting, put on music or pin up references.

Share

'Share' is the final phase of research and involves presenting, reviewing, networking, teaching, publishing and disseminating. For academic researchers, dissemination is focused on journal publications and conference appearances. Within the wider knowledge workplace, the range of outputs is wider but the overall process is much the same.

'Share' and 'discover' spaces have an overlap, as it is often during dissemination and discussion of one project that new ideas for another emerge. Traditional dissemination spaces are closed and by invitation only. Making 'share space' more visible and accessible would create more opportunities for engagement and encourage increased connections between people who may not have been directly involved with the work.

Researchers generally expressed a dislike for the neutral 'corporate' venues typically used for sharing work, which they felt were too formal and stifling. Instead they preferred unusual venues, naming a ski resort and a literary festival as examples of venues that had generated a better engagement with colleagues.

CREATE
Smart Study

Smart Study proposes using existing provision to create a centrally organised network of bookable rooms across different floors and departments. Someone needing a dedicated quiet space to work should be able to book a room anywhere in the network and escape there knowing that they will not be interrupted. Smart Study spaces can differ in size, privacy and facilities, allowing each person to make a decision about what would suit them best. Rooms should be installed with intelligent software. When a worker enters the room using their smart card, the software remembers that person's database and individual preferences. The room then automatically adjusts to how that person left it, changing the lighting and mounting their desktop and digital displays in preparation for starting work.

SHARE
Event Box

Event Box is a range of soft box furniture that can be arranged in multiple configurations to create settings for workshops, informal presentations and small meetings, allowing people to create their own arrangements to suit their event. Situated within open space, this setting encourages passers-by to stop and look, creating a wider awareness of knowledge creation within the organisation. Soft boundaries such as the change in floor surface and colour differentiate the area from the rest of the space, while adjustable screens provide extra privacy and help to reduce ambient noise.

Towards the future knowledge workplace

Our exploration of new settings and concepts for knowledge work – described in this chapter – were underpinned by the emergence of five generic design criteria that respond directly to the individual processes of the researchers who participated in our study. First, spaces should be flexible to cope with evolving needs. Second, they should be tuneable, so people can adjust them to their personal preference. Third, boundaries should define different zones and indicate the function of a space. Fourth, spaces should be comfortable and welcoming spaces so that people can occupy them quickly and easily. Finally, settings should be standalone and independent of the architecture, making longer-term changes straightforward.

Our deep dive into the types of knowledge work that the new wave of academic libraries in the UK are seeking to facilitate held many clues for how we might use the physical environment to promote a culture of learning in the future knowledge workplace. Our findings were in part echoed by a complementary study, entitled New Landscapes, from the other side of the Atlantic. This ethnographic research project, a collaboration between office furniture company Haworth and the Toca consulting firm, emphasised the need for workplaces to prioritise supporting non-routine, creative knowledge work if they are to provide effective environments for 21st century workers, as computers take over more routine tasks. New Landscapes also predicted that office workers will need new tools and methods to evaluate, prioritise and process information in an effective manner. An interesting connection between our review of academic libraries and New Landscapes was in the shared view that the quality of physical settings will continue to be vital in supporting effective knowledge working, despite the growing prevalence of technology, and that the atmosphere of physical settings will become increasingly important too. The New Landscapes study articulated some interesting ideas about ambience and atmosphere, mainly around a debate about craftsmanship, use of natural and recycled materials, and sustainability.

The Saltire Centre at Glasgow University has a large central space that has been divided up using different furniture settings to support varying group sizes and activities

What we learnt from the library

As an alternative model, we believe the academic library offers new directions for knowledge settings in the corporate workplace, which places a growing emphasis on collaborative activities, but remains weak at providing spaces that allow for self-determination and choice. Fearing such flexibility for their workforces, corporate organisations seek out structure, tending to believe that this means a choice between open plan and cellular offices. The evolving academic library provides a landscape with a range of high-value settings that would give knowledge workers the autonomy that they seek, while providing them with the visual and technical resources required to process increasingly complex information.

Within an organisational setting, learning from the library increases the potential for knowledge to be discovered, created and shared, raising learning to the status it deserves within an economy driven by ideas. However our study of researchers in both corporate and academic roles concentrated primarily on individual process in terms of knowledge building. There was far less exploration of the experience of knowledge settings, although some key aspects surfaced. To investigate the psychological experience of working in the knowledge economy, it was necessary to look in a different place for ideas and inspiration — a place of a fantasy and drama and make-believe — the world of the theatre.

New Landscapes

This research study was undertaken in 2013 by Haworth and Toca, a consultancy firm that uses ethnographic research techniques to generate in-depth insights into human behaviour. The study combined observations and interviews with future-casting to create a picture of the world of knowledge work in 2020. Toca recruited 19 knowledge workers of a range of ages and backgrounds and spent two weeks making detailed observations of people within their working environment, recording the way they worked, where they worked, their communications with others and the tools that they needed in order to achieve their goals. This was supplemented by a literature review and interviews with recognised experts in the areas of technology, sustainability, learning and organisational modelling.

The findings from the study have significant implications for the spaces in which we work and for our interactions with technology within these settings. Workspace will need to be 'smart' by 2020: many objects will be able to communicate with each other and, interrogated intelligently, new technologies will have the capacity to improve productivity by generating valuable data about our workplace interactions. The study supported the view that knowledge workers will not only require a variety of quality spaces to support different modes of work, but will also seek stability as a balance to the inherent uncertainty of non-routine knowledge work; offices will be destinations valued for their support of connections, activities and psychological and social comfort.

Right: The LEGO development office in Billund, Denmark provides dedicated settings for different activities, and has a strong focus on supporting social interaction and informal knowledge exchange. Design by Rosan Bosch Studio

Emotional landscapes
Learning from the theatre

Learning from the theatre

Compare time spent in the average office with a visit to the theatre. Our emotional and psychological responses will be completely different. The workplace will offer little by way of spatial depth or atmospheric settings; spaces will be neutral in tone, causing no offence but generating little interest. In contrast, the stage will be rich in visual stimuli, bathed in light and colour, deliberately framing the action and manipulating our senses in line with the narrative of the performance.

If we accept that enhancing the individual's psychological experience is key to improving work environments, then why not learn from the experts? Theatre designers are super-skilled at manipulating our psychological responses, using simple visual cues to evoke the fundamental nature of a setting and the behaviours that might be expected within it.

Having to work with tight budgets and the time constraint of opening night, they are also experts in creating effects that are much greater than the sum of their parts. They create rich and

Traditional European theatre sets used elaborately painted top hung canvas 'flats'

evocative environments using simple, inexpensive components — and the basic physical requirements of swift scene changes or touring productions mean that they work with lightweight, highly flexible elements that stand in distinct contrast to the heavily over-specified, over-engineered modern office.

With this in mind, we decided to take a closer look at the work of theatre designers. Our research began with an in-depth exploration of the history of set design, largely carried out through visits to collections held by museums and universities. We learnt that laboriously painted theatre 'flats' dominated theatre design for centuries, with the first move towards creating environments rather than a picturesque background coming with the development of realism in the mid-1800s. Although scene design was taking steps towards a more three-dimensional use of space, realism consisted of faithfully reconstructing the appropriate setting — for one production, the director reportedly bought the entire contents of a boarding house room and transferred it to the stage, wallpaper and all.

The late 1800s saw the development of a new approach that seemed to have much greater potential for telling us something about how to create evocative and emotive environments without having to lean so heavily on 'realistic' props and scenery. This was symbolism, a period which saw the establishment of the theory of correspondences between ideas, colours and moods, with designers developing intensely evocative settings using a very simple palette of elements.

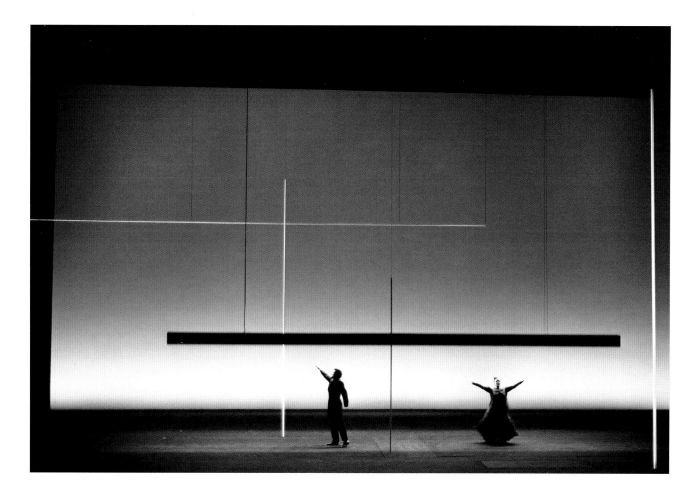

Pierre Quillard, an early proponent of symbolism in the theatre, described the perfect set as "a pure ornamental fiction which completes the illusion by colour and lines analogous to the drama. In most cases, a backdrop with a few mobile draperies will be sufficient to give an impression of an infinite multiplicity of time and space." This was the moment at which a production of Chekhov's *The Cherry Orchard*, for example, would be transformed from real trees on stage to dappled light on gauze. It was this 'maximum effect through minimal means' approach that led to this modernist strand of theatre design becoming the focus of our research.

We looked in particular at the two most important designers of this early modernist movement, Adolphe Appia and Edward Gordon Craig. Both had a particular interest in using standardised, repeatable forms as the basis for their work, using variation in outlines, mass, colour, light and sound as a means of conveying atmosphere. Their ideas were far in advance of their time, and it was not until the mid-twentieth century that their approach was put more widely into practice. It may now fairly be said that their work forms the basis of modern scenographic theory. These two designers — alongside Josef Svoboda, a seminal twentieth century designer whose work is based strongly on their ideas — were fundamental to our study.

Pioneers of modern theatre design

ADOLPHE APPIA, 1862-1928, SWISS

Appia conceived his designs in terms of space, volume and mass, using platforms, steps and ramps to create transitions between upright scenery and the floor. All parts of his settings were three dimensional, creating dynamic, sculptured spaces. He attributed a very precise role to colour, and viewed light as the primary means of unifying and blending all visual elements into one harmonious whole, inventing light projections to complete, modify, animate or even create the decor. Crucially, shadow was as important as light in Appia's work — he believed that light could not exist without its counterpart and, in some of his scenes, the shadow of a cypress tree could constitute the entire decor, present through its absence. His thinking is in sharp contrast to the modern workplace, which tends to be uniformly overlit and located on a single plane.

EDWARD GORDON CRAIG, 1872-1966, ENGLISH

Craig rejected realism in favour of evoking atmospheres using colour, mass, light and sound. Similarly to Appia, he was particularly concerned with volume and light, depending primarily on strong lines devoid of cluttering detail. While colour was central to his work, he frequently worked with seemingly limited colour palettes, breaking down scenic elements to their simplest possible representation, then blending colours and tones to create multiple effects: for example, he used soft green and purple light washes to suggest a mountain swathed in mist. Craig spent much of his career developing a system of non-representational mobile screens, which could be easily moved to create different stage volumes and lighting surfaces.

JOSEF SVOBODA, 1920-2002, CZECH

Prague-born Svoboda can be seen as a direct inheritor of Appia and Craig's thinking. He took a strong interest in technological innovation throughout his career. He was the first stage designer to bring filmic projection to the stage, combining it with live action, and developed a system called the 'polyekran', which used multiple projection screens simultaneously. Svoboda went on to revolutionise stage lighting techniques with a combination of slide and film projections, laser beams, holograms and an innovative aerosol technique that gave light the appearance of three-dimensional solidity.

Vocabulary of effects

This archival research into the work of Appia, Craig and Svoboda led to the development of a scenographic 'vocabulary of effects', breaking down the key elements and techniques of stage design into six categories: light and shadow, levels, projection and effects, screens, colour and vista. These are all aspects of design that can be found in contemporary workplaces, but which are often underdeveloped, or used for purely bureaucratic purposes. In the context of the workplace, these can arranged along a spectrum from relatively permanent installations which require decisions to be made at management level, to more flexible and temporal elements which allow decisions to be made day to day by people working in that space.

'Vista' and 'levels' elements are generally architectural in scale, and placed at fixed locations. In an office, these might be semi-permanent once installed, requiring a larger scale reorganisation in order for changes to be made. 'Colour' is next on the scale; while in some applications (particularly where applied in the form of light), colour might be more open to user control, the colour scheme as applied in graphics, fabrics and wall finishes is relatively fixed.

'Screens' are a more consistently flexible element, with the potential to allow workers to make regular and significant changes to the spaces that they inhabit. As both 'projection and effects' and 'light and shadow' can potentially be changed at the flick of a switch, they are the most flexible and temporal effects, with considerable potential for being given over to local user control. This would generally have to be negotiated on a group rather than an individual level.

As all of these aspects could be used in widely varying ways, the six wider categories were broken down further to create a vocabulary of 26 elements along the lines of an office furniture collection (see overleaf). These elements were developed through conversation with theatre and lighting designers. They both identify and describe design techniques, but can also be used to propose ideas. Most design solutions will use more than one idea, but they do not all have to come into play at the same time.

Application of the vocabulary

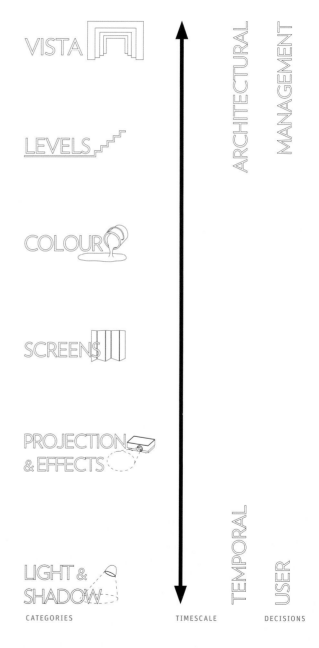

CATEGORIES TIMESCALE DECISIONS

Vocabulary of effects

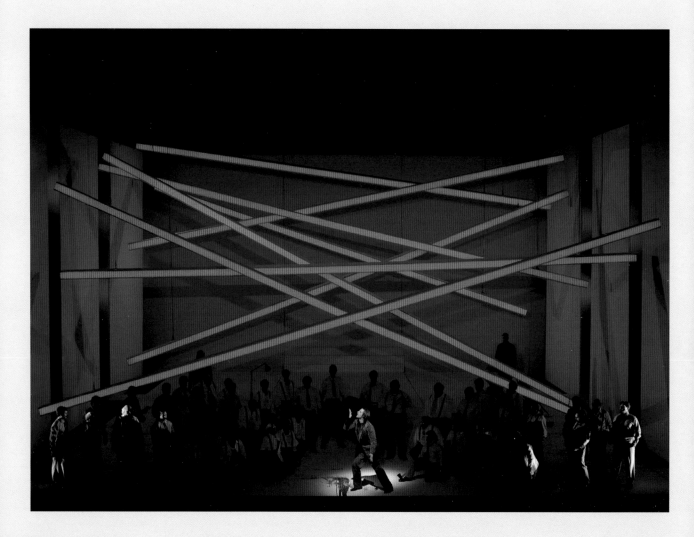

VISTA — EXPANSE

'Expanse' creates a sense of beyond, often by strongly framing a view into a wider space. Appia regularly used this idea to suggest expansive landscapes within the confines of the stage. It can also open up unexpected views, generating a sense of curiosity about what is coming next.

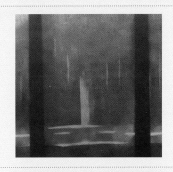

Adolphe Appia, *The Clearing* 1909

VISTA — PERSPECTIVE

'Perspective' is a strongly rhythmic effect, creating a strong sense of forward movement and a distinct visual focus. In the workplace this could create rhythm and movement in circulation spaces, focus on a destination point to make wayfinding easier, or frame a presentation space.

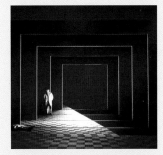

Stage design Benoit Dugardyn, lighting design Mark Jonathan, *Die Entführung aus dem Serail*, 1995

VISTA — FRAME

'Frame' divides two spaces, while maintaining a visual connection between them. It defines difference, and can therefore indicate a change in activity or mood, delineate boundaries or indicate entrance points.

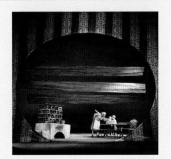

Josef Svoboda, *Strakonicky Dudak*, 1968

VISTA — DEPTH

'Depth' is about creating layers of space, with 'pause points' that arrest the gaze and create a sense of multiple layers of activity. This can be fixed or constantly changing, revealing space that had previously been concealed or only half glimpsed. Depth in particular is often under-defined in offices with repeating modules of low-rise furniture across a large expanse.

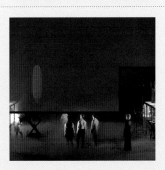

Hotel Pro Forma, *Tomorrow in a Year*, 2009

LIGHT AND SHADOW — TOP LIT

'Top lit' creates 'pools' of light that define an area or highlight an activity, creating a strong visual focus and an intimate atmosphere; this would work particularly well in individual or group concentration or breakout settings.

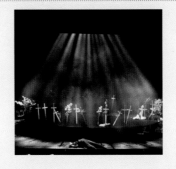

Le Roi Arthus, Bregenz Festival, 1996

LIGHT AND SHADOW — SIDE LIT

'Side lit' is the most frequently used directional lighting in theatre, and is particularly good for creating a strong sense of space, whether as sharp, dramatic contrast, or softer, more intimate lighting effects. Low-level side lighting creates comfortable, intimate focal points within a wider area.

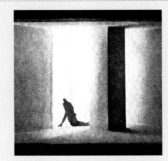

Edward Gordon Craig, set model for Hamlet, 1921

LIGHT AND SHADOW — BACKLIT

'Backlit' is particularly good for creating atmosphere as it is relatively abstract, creating a mood and feel rather than lighting specific objects or areas. It also creates a convincing spatial depth — something that workplace settings tend to lack —and could provide either a soft glow or strong sense of drama against a work or social setting.

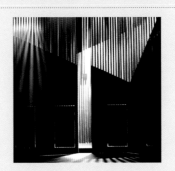

Kimie Nakano, *Yabu No Naka*, 1999

LIGHT AND SHADOW — PATTERN

'Pattern' has the potential to be a textural element in a workplace setting as a versatile and inexpensive way to create ambience and mood. It can be highly evocative — for example, using a dappled light effect to suggest sun shining through trees — or used as a more abstract or graphic effect.

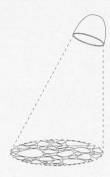

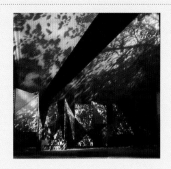

Josef Svoboda, *Juan*, 1959

LIGHT AND SHADOW — SHADOW

'Shadow' gives light its meaning and is generally underutilised in workplace lighting. It can be used to create dramatic, graphic effects, or intimate feeling areas within a larger space.

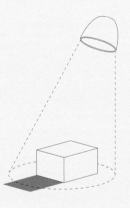

Adolphe Appia, *The Shadow of the Cypress Tree*, 1909

LIGHT AND SHADOW — WASH

'Wash' describes a relatively low contrast light with a very soft boundary edge. It is strongly linked with colour, and lends itself to a calm, contemplative effect.

Robert Wilson, *Pelleas et Melisande*, 1997

LEVELS — REGULAR STEPS

'Regular steps' create a strong sense of journey or arrival. They can be almost processional, giving a feeling of significance to the act of travelling between one space and the next.

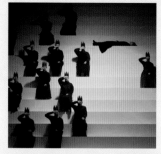

Hotel Pro Forma, *Operation : Orfeo*, 1993/2007

LEVELS — IRREGULAR STEPS

'Irregular steps' also have this sense of journey, but the rhythm is interrupted, creating opportunities for locating different activities along the way.

Adolphe Appia, *Rhythmic Spaces*, 1909

LEVELS — RAMPS

'Ramps' give a sense of continuous flow from one space to another, and can act as a linking element between different levels.

Adolphe Appia, *Rhythmic Spaces*, 1909

LIGHT AND SHADOW — PODIA

'Podia' define distinct levels within which activity takes place. Lowering an area tends to create a more intimate, casual space, whereas raising the floor creates a strong visual focus. Linking podia together works to define different areas of activity.

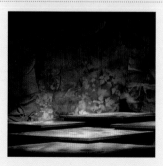

Josef Svoboda, *Jak se vam libi*, 1970

PROJECTION AND EFFECTS — BACKDROP

'Backdrop' defines a whole setting in virtual form. Often used to create landscapes, it allows the passing of time to be illustrated, and suggests expanses of space much larger than the confines of the stage. This kind of projection could define soft boundaries between spaces, or set the mood in different settings.

Josef Svoboda, *August Sunday*, 1958

PROJECTION AND EFFECTS — ACCENT

'Accent' creates a visual narrative and can be used as a kind of punctuation, creating a sense of rhythm to the space. This could be used to support the narrative of a team space, with the option to update imagery as a project develops.

Leiko Fuseya and Beverley Emmons, *A Midsummer Night's Dream*, 2005

PROJECTION AND EFFECTS — TRANSFORM

'Transform' uses abstract imagery, patterns and colour to create a feeling of cinematic expansiveness, suggest place settings and atmospheres, or set rhythm and mood.

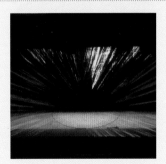

Gunther Schneider-Siemssen, *De Temporum Fine Comedia*, 1973

PROJECTION AND EFFECTS — REVEAL

'Reveal' is a physical effect, used to create layers of depth and translucency. Theatre designers use specialist gauzes that appear solid when lit from one side, suddenly becoming transparent when lit from the other. The technique can be used to quickly change the perception of the depth and size of a space, or to create division without completely closing areas off.

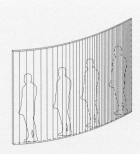

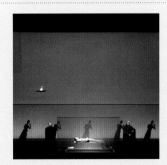

Robert Wilson, *Pelleas et Melisande*, 1997

SCREENS — MOVABLE

'Movable' screens are a theatre design staple and could provide workers with the opportunity to arrange their space as they see fit, making instant changes to boundaries or privacy levels

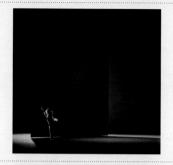

John Pawson, *L'Anatomie de la Sensation*, 2011

SCREENS — TOP HUNG

'Top hung' screens are a development of the traditional theatre flat, and they can be used to divide space, illustrate a setting, or introduce texture and colour. While in a theatre they can only move vertically, they could be shifted in any direction on a ceiling track, or could be re-locatable by being clipped onto fixed points at ceiling level.

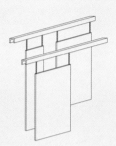

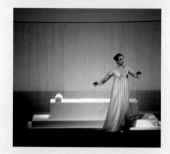

Robert Wilson, *Pelleas et Melisande*, 1997

SCREENS — MALLEABLE

'Malleable' screens are physically adaptable, changing shape or size to fit different scenes or activities. They can be used to create rich, highly adaptable settings out of very simple elements. This could translate into workplace settings that could be quickly and easily reconfigured to suit the needs of their users.

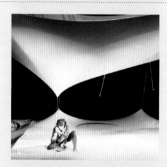

Jaroslav Malina, *A Midsummer Night's Dream*, 1984

SCREENS — STATIC/SCENIC

'Static/scenic' screens create strong boundaries, defining a sense of place. These fixed screens are often more architectural in scale and have a lot of scope for experimenting with materials, resulting in rich, textural effects.

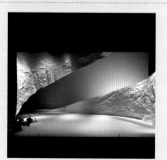

Kimie Nakano, *Vertical Road*, 2004

COLOUR — GRAPHIC

'Graphic' refers to the use of stylised shapes, images and patterns. Graphics have a strong association with identity and branding, but should be thoughtfully used to establish mood or introduce texture, rather than simply mass replicating a company brand.

Maria Bjornsen, *Macbeth*, 1997

COLOUR — WASH

'Wash' is a soft, ambient manifestation of colour, often bleeding from one colour to another across a surface. As an effect, it suggests and enhances mood. It can be an area of permanent colour, but 'wash' also has a particularly strong connection with light.

Edward Gordon Craig, *The Pretenders*, 1922

COLOUR — SATURATE

'Saturate' refers to areas of relatively intense, block colour which is generally even across a surface. In a workplace context, saturated colour is often best used as an accent element, whether as a vivid intensity of colour creating a high energy, exciting space, or with a softer intensity for a calmer, more focused atmosphere.

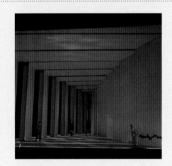

Stage design Hans Schavernoch, lighting design Mark Jonathan, *Salome*, 2007

COLOUR — LAYER

'Layer' involves the combined use of multiple colours, creating a rich setting without the intense visual impact of saturated colour. It can be very evocative, with the layering of subtle, complementary colours used to suggest landscapes or emotions.

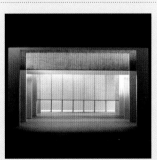

Adrianne Lobel, *L'allegro, il Penseroso ed il Moderato*, 1989

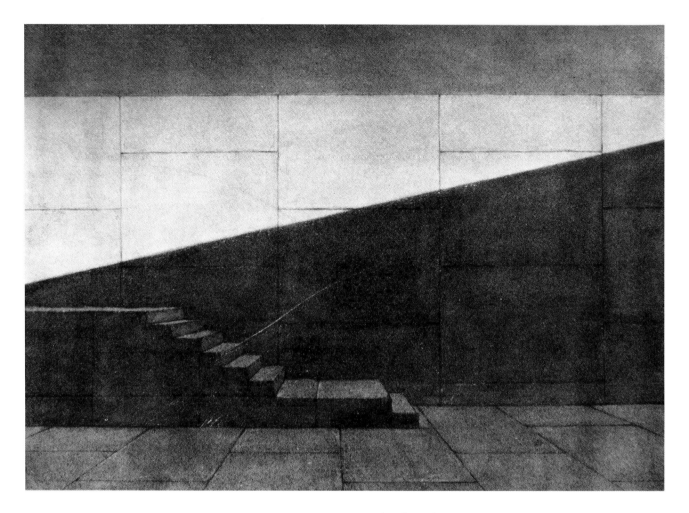

Above: This sketch from his *Rhythmic Spaces* series illustrates Appia's belief that light has no meaning without shadow

Right: Performers manipulate elastic panels to form the set for this production of Shakespeare's *A Midsummer Night's Dream* in 1984

Learning from the masters

In developing our vocabulary of design elements, we swiftly recognised the overriding importance of lighting. It brings the stage to life, creating atmosphere, depth and texture, with the potential to effect dramatic changes with a single flick of a switch. Appia, Craig and Svoboda even developed light as a three-dimensional material in its own right, with the potential to entirely replace a physical set. In contrast, the classic format of office lighting is still a set of standardised luminaires, providing a uniform level of light across

the office floor. We identified huge opportunities for using theatre lighting principles to create variations of light and shadow within the workplace, potentially offering a high level of user control.

Looking at the use of levels in stage design, we saw that Appia had a particular interest in using the ground plane in a very three-dimensional way, exploring the use of podia and steps to create rich, dynamic spaces, which he described as "living spaces for living beings". In contrast, the average modern office tends to operate on only one habitable plane. While there are obviously health, safety and accessibility issues associated with introducing level changes, it is still possible to use these ideas to introduce more richness and spatial diversity. They do not even have to be applied at floor level; changes in ceiling level can create openness or intimacy by raising or lowering the ceiling in relation to the floor.

Our elements around projection and effects draw on the early ideas of Appia and Craig, which led to the introduction of filmic projection in the theatre in the mid-twentieth century. Today video projection is a dynamic and dramatically effective way to provide backdrops and — on occasion — fully interactive scenic settings. The use of lighting and gauzes to create appearing/disappearing effects with a subtle and shifting sense of depth is a form of visual language rarely found in the workplace, where even the most beautifully designed setting tends to be a static image, with no ability to respond to changing moods, occupants or activities.

Edward Gordon Craig first developed the idea of the screen as a mobile device that, together with light and colour, could be used to create an infinite number of settings for any play. Over the course of the twentieth century, screens have been utilised in a huge variety of ways, forms and materials to suggest spaces and atmospheres. While screens are widely used in the workplace, they tend to be somewhat bureaucratic in form and function; taking inspiration from the theatre could result in them being used in a much more strategic and expressive way. Perhaps the most important lesson here is the central principle of scenography — that architectural elements should adapt and respond to the action, rather than being a static element of decor.

Appia and Craig were two of the first theatre practitioners to fully realise the potential of colour to create atmosphere. Craig often used coloured light to create rich, blended effects against simple backdrops, stressing the need to choose a simple, symbolic palette which could be used to evoke a setting, rather than attempting to reproduce it. The four colour elements in our palette — 'graphic', 'saturate', 'layer' and 'wash' — could be applied as relatively fixed colour, such as paint, applied graphics or fabric, or could be utilised as coloured light, creating easily changeable, flexible effects. Colour has been a relatively underused element in workplace design where developer-driven offices have tended to favour 'vanilla' solutions. New lighting technologies that enable colour to be applied or changed at the flick of a switch offer new possibilities.

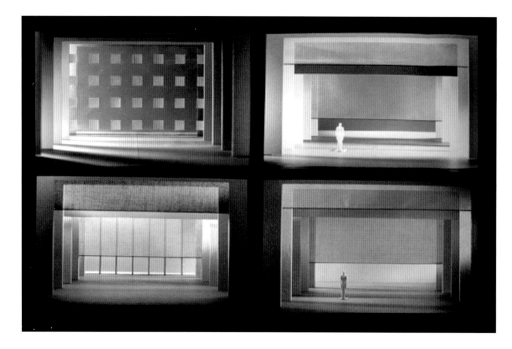

The idea of vista is also an underused concept in many offices, where stepping onto an office floor all too often means being faced with a uniform expanse with few differentiating features. In this category we set out to describe ways to focus the gaze, create a sense of 'beyond', define entry points or create varying spatial conditions. Visual framing is a crucial device in set design, with designers using it very carefully to ensure that the audience's attention is exactly where they want it to be. There is a great deal of potential to transfer these ideas to workplace environments, creating a sense of spatial narrative and delineation.

Shadowing designers

We supplemented this exploration of stage design techniques with research into design process. Our study shadowed two workplace and two theatre designers through the course of a project to compare and contrast their creative processes. Of the workplace projects, one was a traditional, largely cellular new build office in Abu Dhabi. The second was a refurbishment project in the UK where the client wanted to introduce a more open plan, flexible way of working.

One of the theatre projects was a new production where the design had to meet particular challenges inherent in a touring play; the set had to be modular and easily demountable, with enough flexibility to adapt to different venues. The other production was staged in a fixed venue so could work with larger scaled pieces, although still with an emphasis on modularity and flexibility which enabled them to be easily stored and quickly changed between scenes.

Interviews with the designers enabled us to generate a generic research journey for each discipline. For the theatre designers, the first stage was 'Research'. This stage is about understanding the play and generating initial design ideas by reading through the script and researching the company. Both theatre designers were very intuitive about their responses, with one describing how she gets a feeling about a particular colour from reading the script – this becomes the starting point for her work.

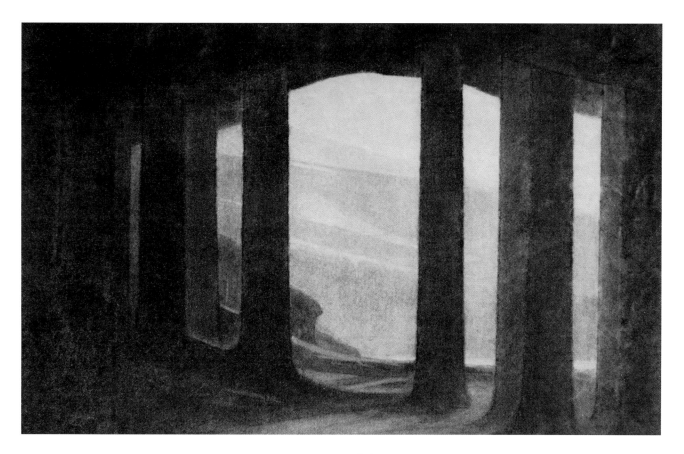

During the second stage – 'Develop' – both theatre designers pulled together images and precedents to develop their initial ideas, supplemented by sketching, rough models and collaging. This was an iterative process, in which they worked in close collaboration with the director. The next stage is 'Propose', storyboarding each scene in detail to facilitate discussions about how the setting would work in practice. This is followed by 'Model', where set designs are modelled in detail, enabling the production crew and cast to quickly grasp the designer's intent and allowing the director to make decisions about staging. The models include scaled human figures, giving a sense of the relationship between the body and space.

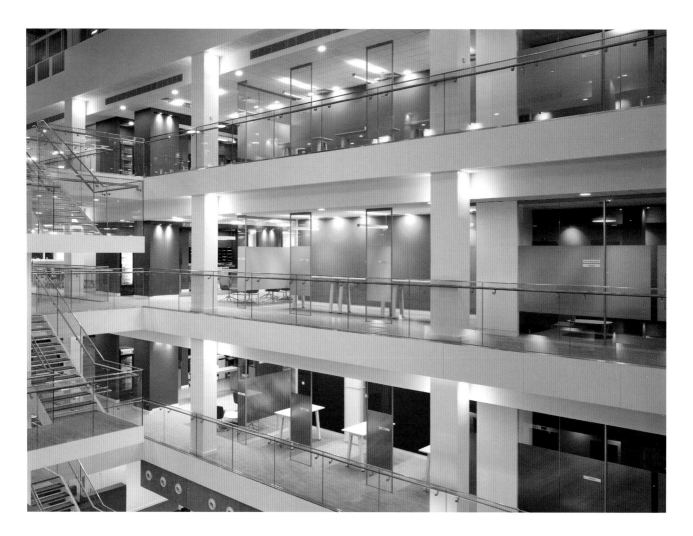

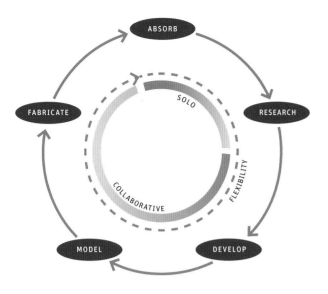

THEATRE DESIGNER

WORKPLACE DESIGN

The final stage is 'Fabricate': the model and a set of technical drawings are given to a fabrication workshop for construction. The layout and final form of the set remain flexible well into rehearsals as the director and actors work on the piece.

Workplace designers work in a different way. The two that we shadowed started with 'Brief'; briefing documents were received from their clients and they began by adding detail, developing a more complete idea of the client's needs. This process included looking at current and proposed ways of working, visual benchmarking and precedents studies. The next step can be described as 'Benchmark'. For the new build project, this involved a rigorous spatial analysis, developing 'best fit' solutions for all of the space types. The refurbishment design team went through a similar process, but were also walking their client through a significant culture change, moving to new ways of using their space. This required a much more consultative and iterative series of workshops and meetings that had not originally been planned for.

The third stage was 'Propose', where both design teams worked up detailed proposals including mood boards and visualisations. This was developed into 'Detail', where schedules and drawings were prepared for tender and construction. Some sketch modelling and testing of full-scale prototypes was carried out. The final stage is 'Construct', when the project goes on site — at this stage the design is theoretically fixed. Any flexibility generally comes from having to manage unforeseen issues or client changes on site.

We observed a number of striking differences between the workplace and theatre design approaches. The theatre designers were able to work in a very instinctive, intuitive way, developing concepts until something 'feels' right. On the other side, the workplace designers were part of a much more logical, mathematical process, establishing parameters by referring to benchmarking precedents and statistics.

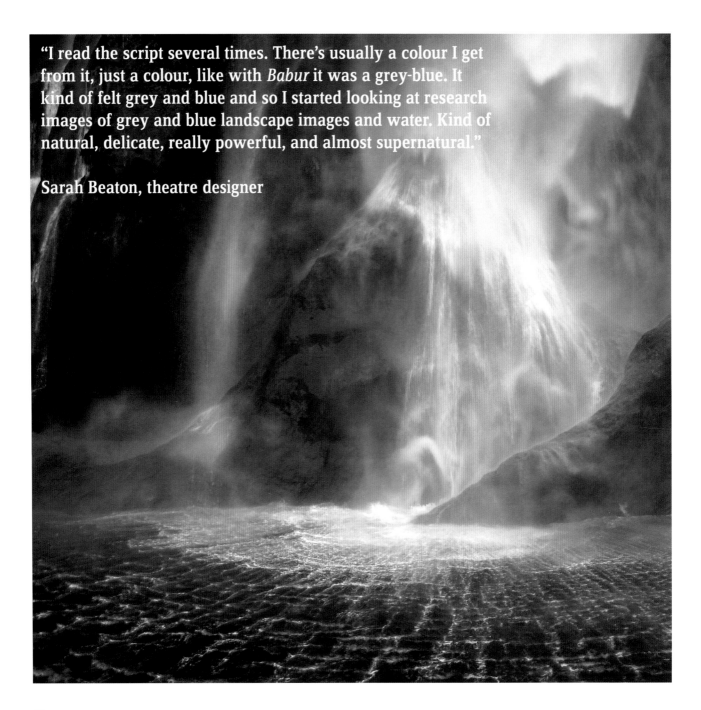

"I read the script several times. There's usually a colour I get from it, just a colour, like with *Babur* it was a grey-blue. It kind of felt grey and blue and so I started looking at research images of grey and blue landscape images and water. Kind of natural, delicate, really powerful, and almost supernatural."

Sarah Beaton, theatre designer

"It's strange. It's almost mathematical the way the process is thought through....you cannot underestimate how much of that goes in."

Senior interior designer, Aedas

A second point of difference was the level of flexibility in the design process. For the theatre designer, the configuration of many of the set pieces was flexible almost to the end of the rehearsal period, with many of these final decisions developed through physical use. In contrast, once a workplace project has reached the point at which furniture has been ordered, there is little flexibility, and even less once the building has been occupied. At this point, it becomes difficult and potentially expensive to make changes to the office floor. To develop the type of 'design through use' approach that is familiar in theatre design would be a new way of approaching workplace design. The most realistic way of replicating this idea in an office may be to create settings that are sufficiently flexible to allow users to rearrange them as they settle into patterns of work in a new space. We also observed that the theatre designers worked in a collaborative framework throughout the project, with active input from the actors who would be working in the space. In contrast, the workplace design teams were exposed to far less end user participation in the decision-making process.

Left: Co-design workshops were held
to engage with the design community

Below: Each group created a board
that used the theatre vocabulary to
respond to a design brief

Application to the workplace

The archival research on the pioneers of modern theatre design and the shadowing of both workplace and stage designers taught us a lot. The next step was to begin to apply the theatre vocabulary to workplace environments. This was done in three stages: first, a series of collage studies directly transposed elements of a set into a 'blank canvas' workspace; second, we retrofitted the new vocabulary of stage elements into pre-existing high-profile workplace projects to see if we could formularise design decisions that had been made intuitively; and third, we organised a series of co-design workshops with more than 50 architects and designers to test the vocabulary and gauge its usefulness.

The collage exercise demonstrated quite clearly that theatre design ideas can transfer very effectively to a workplace setting, and showed how a few very simple moves can make a really significant difference to the look and feel of the space, for example, using coloured gauzes and vertical elements to enrich the space by adding colour, depth and rhythm.

For the exercise on retrofitting the new vocabulary of stage elements into existing workplace precedents, we deliberately chose offices that create mood and atmosphere in a relatively economical way. Although not consciously drawing on theatre design for inspiration, the one thing they have in common is that elements such as colour, texture, light and framing have all been used to create a 'set' for work with the aim of evoking a particular ambience, encouraging specific behaviours or expressing culture.

The co-design workshops were held as part of Clerkenwell Design Week 2012, a three-day festival at the heart of London's design community. Participants were split into groups and given a brief, the theatre vocabulary, and a wide variety of precedent images, materials and colours. Each brief was based on real workplace challenges identified during the research. Participants were asked to think of simple, high impact ways of introducing atmosphere into lean spaces and to consider what user control or flexibility

Macquarie Bank, Sydney
Clive Wilkinson Architects, 2009

Framing, colour and light are used to create a clear differentiation
between work zones, encouraging specific behaviours in the two
areas. The frame creates a clear sense of 'this side' and 'that side',
while keeping the whole connected. The saturated colour creates a
warm, intimate atmosphere and the top lighting — soft and low for
ambient light, and focused local task lighting — adds to the sense
of atmosphere while encouraging quiet, concentrated work.

BBC, London
Allies and Morrison, 2004

Top hung translucent curtains give meeting areas a feeling of privacy, creating intriguing, half hidden depth when pulled across. Hanging 'feature lights' create a more informal feeling than standard luminaires. Feature light boxes in saturated colours give an impression of vibrancy without being overwhelming, and differentiations in floor colour and texture make zoning clear and add variety and texture at floor level.

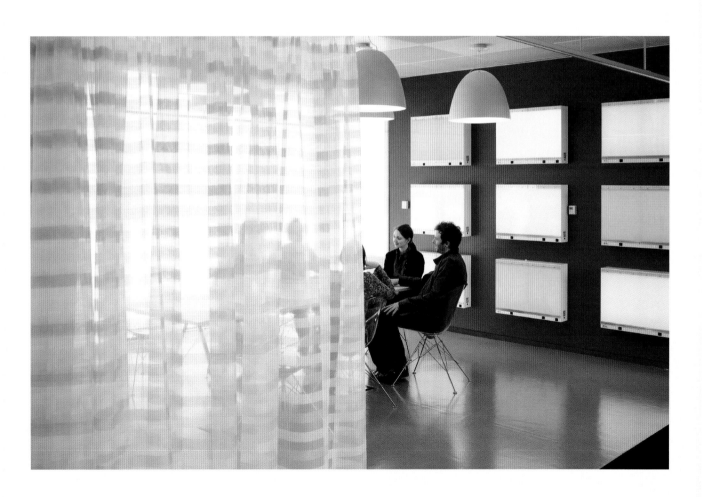

Collage Study using the set design from *L'Allegro, Il Pensero ed Il Moderato* by Adrianne Lobel, 1981

This collage study transposes Lobel's set onto a lean office environment, demonstrating the difference that a few simple changes can make to the look and feel of a space. Screens in multiple tones within the same colour palette create richness without being overwhelming, while varying translucency creates a sense of division without closing spaces in. Vertical lighting elements along the circulation route create a soft perspective effect.

Overleaf: Set design for *Erwartung* by Robert Wilson

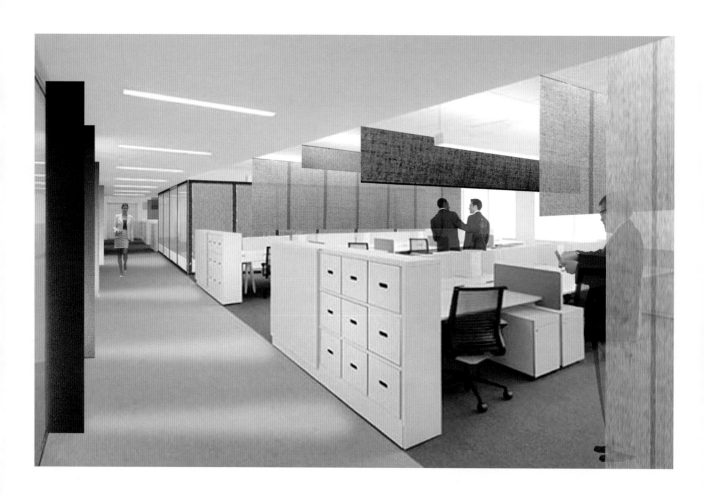

could be included. They were given just 20 minutes to respond, requiring them to be quite intuitive about their choices.

People generally engaged with the theatre vocabulary and the ideas behind it quickly and with enthusiasm. There was very strong interest in the idea of having spaces that can adapt in some way to various needs, whether this was to do with physical reconfiguration, or using light and projection to change the mood and atmosphere according to the activity. Virtually all of the groups picked up on the idea of using light and projection, not just as functional elements but to add an experiential layer to workspace, suggesting that this is a very real opportunity for further development.

The use of flexible elements was often balanced out by the introduction of framing and boundary pieces to define different areas or work settings. There were also several repeating themes in terms of the things that people felt were most lacking in workplace design; these centred on introducing a wider range of textures and using more natural materials, as well as perforated or gauze-like materials to create layers of translucency and a greater sense of depth. There was also strong interest in the idea of a new temporal paradigm in workplace design, enabling change to happen from week to week, or even day to day.

What we learnt from the theatre

These ideas tie in with themes that came up repeatedly throughout our investigation of stage design. Two major considerations in any production design tend to be cost and weight; budgets are often tight, and there may only be a couple of minutes between scenes in which to change the setting. This results in sets that are lightweight in construction and flexible in use, allowing for changes to be accomplished quickly and easily. Conversely, materials in offices tend to be substantial and heavy, with changes in layout requiring a blue-suited team to come in over a weekend.

Theatre designers are also experts in using scale, depth and framing to create visually interesting and clearly defined spaces with a strong spatial narrative; this can enhance visual interest, create a

sense of variety and aid wayfinding by making different zones and destinations clear from a distance. Such an approach addresses the emotional and psychological needs of the individual — a factor we have identified as important to the future of office design.

Two important areas emerged from our look at theatre design, each with scope for new product development in the workplace. The first is architecturally scaled elements, such as framing and levels; the second is more lightweight, flexible pieces involving screens, coloured light, printed graphics and projections that would overlay a new, more temporal layer onto workspace and respond to changing user needs by giving more local control and a greater range of effects.

To create more expressive and effective office environments for people, we need to explore new ways to move from workspaces that are lean, static and fixed to ones that are enriched, dynamic and flexible. The simple and direct techniques pioneered by modernist theatre designers — 'maximum effect through minimal means' — are inspirational, we believe, in helping office designers and their clients to think about the psychological wellbeing of the workforce, and not just their physical comfort.

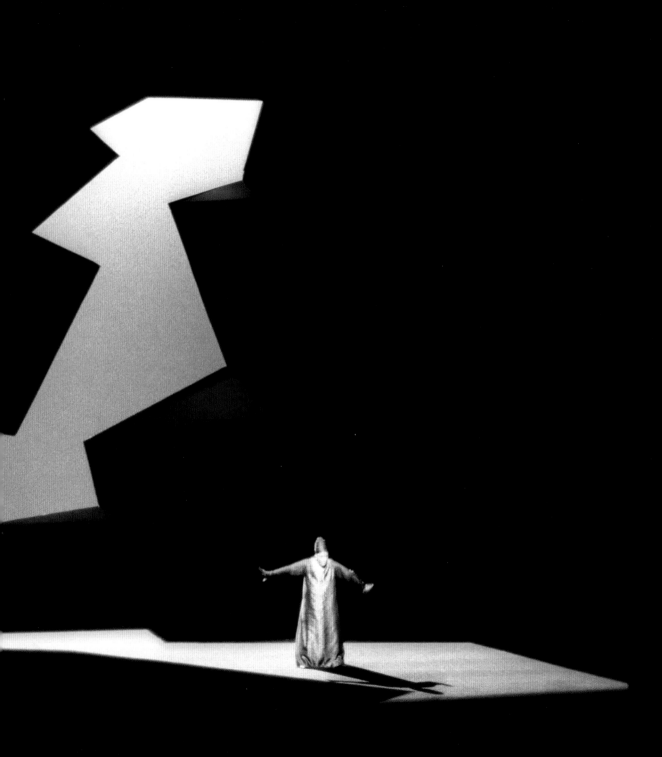

Flexible interventions

Learning from the urban realm

Learning from the urban realm

Even though we watch performances on the stage in the company of others, the art of theatre design is essentially aimed at the psychological responses of the individual. The play, opera or dance is going on inside our heads. Yet we are also undeniably social animals at work and in life, and our interactions with others are critical to productivity and wellbeing. In order to understand better how the shared experience of the group is shaped, we decided to investigate design expertise and exemplars in a different area — the urban realm.

Designing effective social and collaborative spaces is becoming ever more important to bringing people together in the workplace. Against a background of technological change in which people now have the tools to work anywhere at any time, companies faced with rising real estate costs are trying hard to address consistently low occupancy rates in their office buildings. They need to give people a reason to congregate in the workplace. However, for all the talk of change, many workspaces remain physically inflexible and behind the curve of rapidly changing patterns of work.

With this in mind, we looked to the flexibility and agility of temporary urban events — festivals, markets, pop ups and so on — as a model for informing the management of change, unpredictability and social experience in the workplace. We focused on these transformative urban settings for a number of reasons — we were interested in the ways in which they can be quickly and intuitively understood, in how social interaction takes place within their flexible structures, and in their ability to adapt to changing contexts and needs.

Perhaps most importantly, temporary event designers manage to create strongly experiential and distinctive places that draw people in, using adaptable, inexpensive and temporary components. The enduring popularity of these types of urban events lies in a kind of transient magic, whether it is a market that serves two thousand people in the space of four hours, a cinema in a stairwell, or a car parking space that becomes a fully planted park for a day.

Temporary events also meet social, cultural and economic needs in the city in ways that more traditional approaches to urban design and planning are less well equipped to do. The rise of such urban events is evidence of a need to change the way in which strategic planning is approached, an increasing recognition of the importance of shared public space, and the value of consultation in making 'places' rather than 'spaces'. Their design is focused on use, rather than simply creating aesthetically pleasing set pieces.

Charting the parallels

In this context, we immediately saw the parallels with workplace design. Indeed it is easy to view the workplace as a kind of city, with all of the associated considerations around planning, movement, activity and creating spaces for people to share. Office design and planning needs more flexible approaches in exactly the same way as urban design has sought to escape the shackles of the rigid city masterplan. These have traditionally been long-term development frameworks that set out a vision of a fixed end state. In a similar way to conventional workplace planning, this approach can be criticised both for overlooking subtleties of function and use, and for lacking the flexibility to respond to unpredictable circumstances.

A number of urban design practitioners are now identifying an alternative approach that works on the basis of phases of smaller initiatives that move towards a more loosely defined end state. In contrast with longer term urban planning, this permits a trial and error approach, with a level of flexibility that can adapt to changing

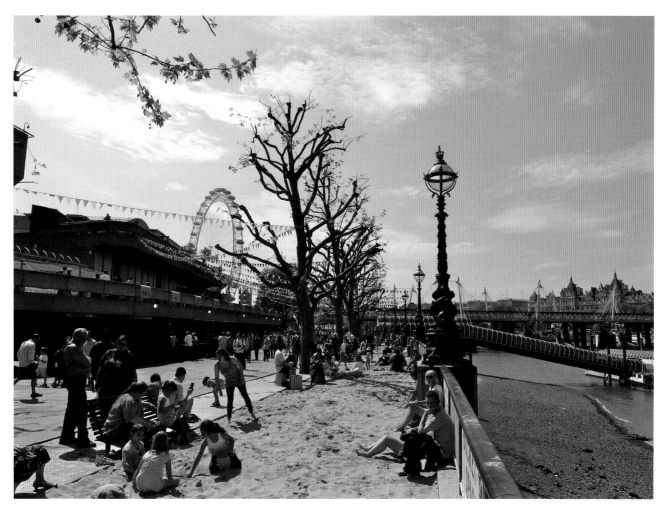

In contrast to the uninspiring and under occupied nature of many office environments, temporary urban events use simple techniques to create vibrant and appealing social spaces. Shown here: temporary beach on London's South Bank

Above: An example of a traditional masterplan, setting out a fixed long-term vision.

Far right: Attached to an existing stairwell, this temporary cinema is a good example of a 'parasitic' intervention

needs and conditions as the project develops. This allows for a much more collaborative design process to be achieved with the communities involved, and for ideas to be tested without over-committing time and resources.

In the course of our research, we consulted with Peter Bishop, a London-based urban planner with extensive experience in local government. Bishop's view is that this alternative process is better able to build community over the course of the project and enable people to achieve more meaningful relationships with the cities in which they live. "Cities cannot function properly without public space," he explains.

"It provides the locus for exchange and informal transactions, and is where citizens meet, gossip, parade and rebel. It is in essence where civic life flourishes."

Much the same can be said of the social and breakout areas, dining spaces and informal collaborative meeting zones of the office — this is where the civic life of the workplace flourishes. Bishop's view finds an echo in a Demos report (2005) that argued that, "Public space is better understood less as a predetermined physical space, and more as an experience created by an interaction between people and place." Other studies have expanded this idea. A report by the Joseph Rowntree Foundation (2006) identified a number of factors that are important in creating shared social spaces. These include familiarity with spaces, regular use, spaces enduring over time, and facilities that give purpose to a space and enhance its social vitality.

Three themes to explore

To be able to learn from temporary events in the urban realm, we decided to look at three particular themes. The first was social interaction. As people are increasingly able to work anywhere, they are more likely to come into an office in order to interact with others. What could urban events that generate intense bursts of social activity tell us about what brings people together? The second theme was communication. We wanted to learn about how temporary settings use informal cues to let people make quick and intuitive decisions about where to go, and how they create atmosphere and identity in simple, low cost ways. Third, we were interested in the physical environment — in structures, furniture, layout and circulation.

We broadly identified four categories of temporary event — interventions, festivals, pop ups and markets — and set out to explore and map their characteristics. What could these low cost, high impact, flexible events tell us about the future of workplace design?

Interventions

Interventions are generally small scale and short lived, often lasting for only a day. They are about making temporary changes that briefly transform the way that a space is used or perceived. We identified three categories of urban intervention, which we named 'reprogramme', 'parasite' and 'object'.

'Reprogramme' is about transforming the use and meaning of a space, placing furniture and props to spark new meanings and activities. For example, Parking Day turns metered car parking spaces into temporary public parks. Each installation varies, but there are some fairly consistent features. The boundaries are clearly defined to ensure a sense of differentiation from the rest of the street — this is generally achieved using a change of surface, often accompanied by plant pots or furniture around the edges. All of the components are lightweight and low cost and the furniture is relatively low, inviting people to stop and linger. Overall, the project demonstrates that a lot can happen in a short amount of time and space.

'Parasite' describes a structure or activity that attaches to existing architecture. Stairway Cinema involved building a temporary cinema into a stairwell near a bus stop. The intervention was reliant on the existing building as the basis for the structure and on the presence of a bus stop to generate its occupation. The distinctive colour and form gave it a clear presence in the streetscape, encouraging people to come and investigate. It was made up of lightweight framing and cladding that made it easy to assemble and install using a small team of people. Although there was no furniture, cushions were placed on the steps to make it clear that people were invited in to sit down.

'Object' introduces a complete single structure into a space, resulting in a new set of interactions and behaviours. Picnurbia is a summer installation in Vancouver, located at the edge of a busy square with a shortage of usable public space. The project created an 'uber-picnic-blanket' on which people can come together. As with the other examples, it has a clearly defined boundary and a distinctiveness that encourages curiosity and therefore use. In this instance, the whole surface is habitable, with integrated umbrellas and shared tables to provide people with somewhere to congregate.

Left: Picnurbia in Vancouver is an example of an 'object' style intervention, inserting a single structure into the urban landscape

Below: Parking Day reprogrammes space by turning car parking spaces into temporary parks

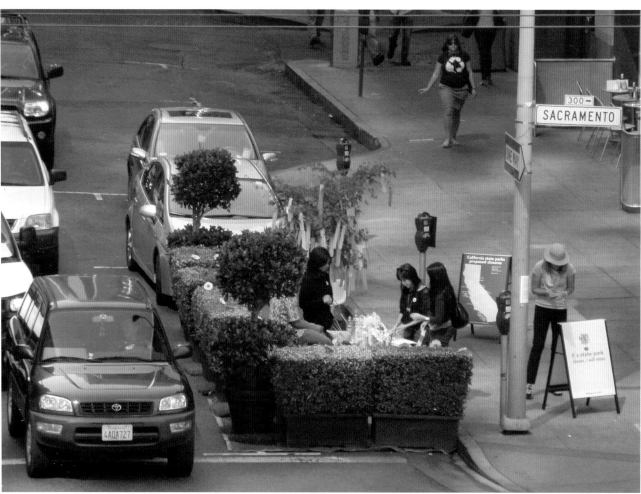

This project for a design festival in London in 2013 consisted of a series of 200 low cost chairs with interlocking shapes that allowed them to be placed in a wide variety of configurations, making spaces to 'rest, play, eat, perform and observe'. The chairs had a distinctive triangular design, clearly differentiated from the other outdoor furniture in the area, and were painted in a limited palette of colours, giving them a clear identity as a group installation. They were very effective en masse, creating a gathering space and prompting people to enter the area to see what was happening. This was about satisfying human curiosity as much as it was about creating a space to occupy.

Pop ups

Pop ups are a much publicised urban phenomenon and are closely associated with the offer of goods or services; most are shops, restaurants or bars. This is a business model that aims to build relationship with customers by offering a distinctive experience or a feeling of exclusivity and often combines retail activity with events. We identified three categories of pop up – 'existing', 'new' and 'reprogrammed'.

'Existing' pop ups work on the principle of occupying and transforming vacant spaces, and the scale of transformation varies from simply painting and rebranding to creating fully immersive temporary environments. The pared down approach is simple and stylised, often using repurposed or recycled furniture and materials, with all of the fittings free standing and independent of the architecture. Immersive settings take a consciously theatrical approach, using props, lighting and set dressing to create spaces that are often highly detailed

reconstructions of complete environments. For example, the Heinz pop up cafe in London fitted out a retail space as a domestic kitchen, complete with children's drawings on the walls and staff working in character as 'mums' and 'dads'.

'New' structures house pop ups on vacant pieces of land, or as temporary or movable units in city centres. These events frequently involve repurposing existing units such as shipping containers, but can also involve creating entirely new structures. Studio East Dining was a temporary restaurant associated with the opening of the London 2012 Olympics. Erected in just four weeks, it was set on the roof of a construction site overlooking the Olympic Park. It was a simple frame and cladding construction using scaffolding and sheet plastic from the site. Shared bench-style tables and warm lighting created a cosy space that encouraged people to interact.

'Reprogrammed' pop ups create an activity in a space that is usually used for something else. They are similar to interventions in terms of transforming the occupation and use of a space, but

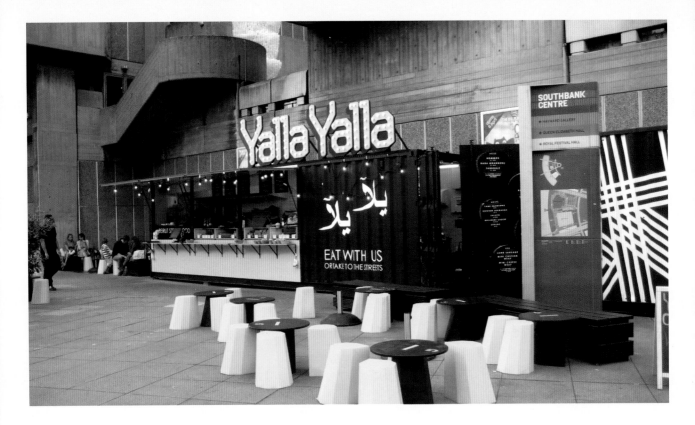

POP UP
Yalla Yalla

Yalla Yalla is a Lebanese restaurant with two permanent locations, which opened a summer pop up on London's Southbank in 2012. Located in the shade of the Royal Festival Hall, the pop up seated up to 40 people, and with numerous other restaurants and events in the area, establishing a clear identity was particularly important. The brand colour — yellow — was used extensively as a clear and simple way to make an impact in the temporary space. In addition, Yalla Yalla used distinctively shaped furniture, lighting and a series of props — chiefly traditional Lebanese stoves — to establish the boundaries of its space within the larger area.

With limited time available to set up on site, the restaurant was reduced to the essentials, with all of the components existing as a layer. The kitchen was pre-installed in a repurposed shipping container that served as an anchor point for the restaurant. This was transported as a complete unit, then simply connected to the services once in place. The seating was mostly low and informal, generating an ad hoc feel that helped to make people feel comfortable about moving furniture around to suit the specific needs of their group.

tend to be larger scale, last for longer or run on a more regular basis. Examples include the trend for temporary cinemas in restaurants and hotels. These events are generally about a reduction to the essentials – the focus is on the novelty of the experience, rather than a highly finessed design. A cafe in South London runs a pop up cinema in its storage unit – this simply comprises a screen and rows of folding chairs, with a temporary kitchen to supply people with food.

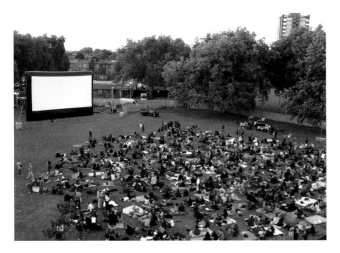

Festivals

Festivals are larger scale, outdoor events taking place in cities primarily during the late spring and summer months. We identified two main types of festival – 'distributed' and 'locational'.

'Distributed' festivals are located across an area of the city, and might encompass buildings, exhibition halls, parks, squares and streets, with visitors moving between different venues and events. The London Festival of Architecture, for example, is a biennial festival that takes place at various sites across London, with three geographical 'hubs'. A significant focus is on encouraging people to use London's public spaces and, with activity so distributed, the organisers had to put a lot of thought into how to move people between locations. This took the form of a colour-coded map that people could carry with them, coupled with visually distinctive pavilions and structures placed at key nodes to draw people intuitively in that direction.

'Locational' festivals take place on a specific site with clear boundaries and generally have a limited and tightly controlled number of entrance/exit points. The Greenwich Summer Festival was organised to tie in with the 2012 London Olympics. The design language referenced an English summer fair, using clearly recognised props and structures – a bandstand, deckchairs, bunting, village crossroads-style signage and white picket fences – to create a sense of nostalgic Englishness. The various activities – music, circus performances, food and theatre – were clearly zoned, with good visual links between them to maintain a smooth flow of movement around the site.

Top: Somewhere to sit, a screen and an interesting location are all that is needed to create a well-attended cinema

Bottom: Carmody Groarke used recycled scaffolding materials to create a temporary restaurant on a rooftop for the Studio East Dining project in Stratford, East London

FESTIVAL
Clerkenwell Design Week

This distributed festival takes place in Clerkenwell, an area in London that is home to numerous creative businesses, architecture and design practices. In addition to furniture showrooms, the festival utilises local public spaces and three historic buildings, which act as the main hubs. As many of the showrooms that take part are scattered around the area, moving people around the site is crucial to the success of the event.

The organisers worked with artists and designers to create small scale installations that are 'soft' links between the three hubs, acting as landmarks to draw people through the site and providing opportunities for interaction along the route. Along with distinctively branded temporary signage, these modular constructions were generally placed at key decision points to provide visual wayfinding cues.

Encouraging social interaction is a major part of the event. All of the showrooms that take part are aiming to bring visitors through their doors, and networking plays a major part in the proceedings for both exhibitors and visitors. Several showrooms used interactive activities to draw people in; these were often located on the pavement outside, aiming to encourage people to pause, participate and then come in.

Below: Distinctive bright pink signage and specially designed structures act as landmarks to draw people through the site and indicate the boundaries of the event

Far Right: Whitechapel Market is a classic London street market, with stallholders setting up from scratch every morning

Markets

Finally, we looked at outdoor markets in the urban realm. Markets can be considered one of the key sites of public space in the city and take many different forms. We identified five types of market, each with different characteristics in terms of frequency, use and structure: 'daily'; 'weekly/regular'; 'weekly/rotating'; 'seasonal' and 'moving'.

'Daily' markets are often located along a thoroughfare and tend to have established regular traders who are there every day. Whitechapel Market in East London, for example, is a classic urban daily market, offering groceries, clothes and household goods to a predominantly local customer base. The market runs along the high street, creating straightforward, linear circulation. The units are all designed to be easily packed away at night and consist of either an adaptable mobile frame or a standard kit of parts which can be used to create a variety of shapes and sizes as needs change.

'Weekly/regular' markets are held on a regular basis, but often only on one or two days a week. They tend to have a more specialised offering and are likely to draw people in from further afield. Columbia Road in East London is a popular market destination on Sunday mornings, when the street is transformed by the presence of a flower market. The stalls line both sides of the street, facing towards each other, creating a natural boundary to the market activity. As the street is comparatively narrow and gets very busy, there is a real intensity of activity, with numerous local cafes and pubs making it an attractive social destination.

'Weekly/rotating' markets are held on several days of the week, but with different traders and products on offer each day. Again, they are likely to be a destination point in and of themselves. Spitalfields Market in East London is located in an old market hall and stalls rotate between antiques and collectables, art and design, and music. The stalls are set up in a grid, allowing for a meandering kind of circulation. They are all made up of standard flat pack pieces, which stallholders can personalise as required. Food and seating are located around the edges of the hall.

'Seasonal' markets run at specific times of year — often around Christmas. These markets are often closely related to other ancillary activities, such as bars, restaurants or entertainment. The South Bank Christmas Market is one of the largest in London, with German-style wooden huts located along the River Thames. These are built off site and moved in as complete modules for an efficient set-up, with each stallholder customising their own unit using lighting, display and surface treatments. The overall layout is designed to fit the natural flow of movement along the South Bank, with food and drink stalls placed in two clusters — one where there is relative shelter offered by a bridge overhead, the other near existing public facilities.

'Moving' markets are those where traders occupy several different market sites on different days of the week, either transporting their own structures around with them, or moving from stall to stall at different sites. Farmers and produce markets are good examples of this type.

MARKET
Brockley Market

This is a small farmers market located in south-east London; it opened in September 2011 and now draws in up to 2,500 people on each day that it runs. It is located in a car park that belongs to a local college; while the car park is often full during the week, it is completely vacant on most weekends. The market sells both hot food and fresh produce and the organisers have tapped into the current trend for street food, which is a major draw. This market is very much a social event, and people often make specific plans to meet there. The market organisers provide several sets of benches and tables to accommodate groups. The traders are regular and some partnerships have developed between them, combining specialities to provide customers with a wider range of choice. With strong local attendance, the market is also used as a forum for other groups to engage with visitors, including community police and activist groups.

There is a clear brand for the event, with a logo, distinctive fonts and graphics, and posters placed as markers along the main routes to the market. Signage is largely informal and provided by the traders to advertise goods and services. It is always independent of the structure and surroundings, allowing for it to be changed without making wider-scale alterations.

The general aesthetic is deliberately rough and ready; a line of handmade bunting wrapped between tree trunks indicates the boundaries of the market, and recycled scaffolding boards are used to make the tables and chairs. Three types of structure are in use: pop up canopies, modular market stalls comprised of metal components that slot together, and customised vans that can be driven onto site and set up as mobile units very quickly. Generous circulation provides plenty of space for people to browse without holding up the crowds, while clear zones and lines of sight allow people to make quick, intuitive decisions about where to go.

Above: With small traders only able to offer a limited range, regular traders form partnerships to widen their offer

Right: The market draws large crowds from the local area, becoming a important site for informal social interaction

Social interaction

Our immersion in the street culture of London and other cities proved a rich terrain in terms of helping us think afresh about an alternative model for office design. The changing nature of the workplace meant that social interaction was one of the key reasons for looking at temporary urban events. We were particularly interested in looking at the factors that supported or influenced social interaction in some way; these were identified as density, provision, exchange, novelty and participation.

Sites with a high density of activity were most likely to generate chance encounters and support interaction between people who did not know each other. Provision of complementary activities and settings encouraged people to spend longer at a location – for example, providing shared seating near hot food or some form of entertainment. Exchange relationships play a significant role; many of these events are commercial enterprises, looking to build relationships with customers, but they often involve sharing knowledge and skills in temporary workshop style settings.

The novelty of the experience was a factor in attracting people and encouraging interaction, with people sharing their reactions to the event. In terms of people who do not already know each other well, interactive or unexpected experiences were most likely to spark a conversation. Finally, the idea of participation is a significant factor in the draw of many temporary events; a feeling of being part of something, of sharing an experience that is significant or unique in some way.

The more we understand what kind of social interaction will take place, the better placed we become to support it. So we looked in particular for conceptual frameworks that might aid this process and found one that was especially useful – this was developed by interaction design researcher Martin Ludvigsen and based on the eminent Canadian sociologist Erving Goffman's rules of interaction. In this framework Ludvigsen describes four different levels of engagement with a social situation – distributed attention, shared focus, dialogue and collective action.

Sacrilege by Jeremy Deller, a touring inflatable Stonehenge; the sheer delight in the experience acts as a conversation starter

Framework for social interaction

Researcher Martin Ludvigsen describes the levels of engagement with the social situation, or the attention given by a participant to the overall situation as opposed to their own individual activities.

Distributed attention
The first level is when people are simply present in the same space. If nothing is the apparent centre, then participants will have different foci around the space and, seen as a social situation, the level of interaction will be very low.

Shared focus
At this level, something is happening within the space that draws everyone's attention towards a central point, even though they may not be actively interacting with each other. This shared focus is then the organising point of reference, and single encounters might cease as the attention of all is required at the situational level. As such, the shared focus can introduce a centre and an audience.

Dialogue
At the dialogue level, people are engaging in a shared activity and influencing each other's experience. Here, the 'dialogue' refers to a two-way communication and interaction that was not present in the earlier two levels. It may be either a sustained interaction, or a brief dialogue in response to an external stimulus.

Collective action
Closely related to dialogue but with a shared subject, the last level of the framework is that of collective action, when participants are working together towards a shared goal and are engaged in, on an overall level, the same activity. Collective action happens when the goals of the participants overlap, not only with each other, but with the goal or purpose of the gathering at large.

Transposing these types of interaction to a workplace setting can be summarised as the following: co-presence, co-attention, co-exchange, co-action.

Communication

The second area of learning was related to communication, from signage and orientation to creating an identity and suggesting moods and settings. Signage at temporary events is often minimal and informal, allowing people to make quick decisions about where to go without overloading them with options. It tends to combine physical signposting with clear visual landmarks to create legible, intuitive environments, and relatively permanent signage is used alongside more flexible or temporary solutions to allow for simple adjustments as things change over time.

Making the most of people's intuitive behaviour was widely used across the different categories of temporary urban event. People will often instinctively follow a marked path, and these were used to direct people to entrances or to move them around a space. Boundary markings at floor level blur the divisions between spaces, encouraging people to come in; people will also naturally tend to gravitate towards canopies or sheltered areas. All of these findings have clear relevance in the workplace in terms of creating a legible environment which can be easily navigated, particularly where large open floor plates are involved.

Many events use props and signifiers to evoke particular settings or suggest behaviours. Props are quite straightforward accessories that are used to help to create an atmosphere, or simply to provide an element of theatre by placing objects where you would not normally expect to find them. Objects with more embedded meaning can be thought of as 'signifiers', using things that are familiar and have particular associations to play with the meaning of the space in which they are contained. An example of this is the Flying Grass Carpet project, which referenced the archetypal Persian rug to create a shared urban commons. These link back to the idea of tapping into intuitive behaviours, using design elements that have strong behavioural associations, such as a pop up pedestrian crossing that many people automatically used as if it were an official installation.

Temporary events aim to deliver an experience, and creating a sense of identity and atmosphere is a vital aspect of the design. Some events do this very simply, using simple graphics and colour palettes and a small range of stylised props and accessories, often using simple recycled or repurposed materials to create an informal, tactile setting. At the other end of the scale, fully immersive settings offer visitors a very specific experience. This has a lot of overlap with stage design in terms of using colour, scenery, lighting and props to create temporary but richly atmospheric environments.

In the workplace, such an approach is relevant to think about how we might build the identity of a specific environment, making it a destination in and of itself. Breakout and social spaces at work can be a bit 'placeless' and purely functional, with too little differentiation from the standard working environment to attract people away from their desks. Using props and signifiers in the workplace does not mean a reliance on gimmickry — as in our examination of stage design, it is often about a reduction to the essentials, thinking about what defines a setting and what the minimum might be required to give people the right cues.

Left: Some pop up events use
theatrical techniques including
lighting, props and costume to create
intense, immersive experiences

Below: The Flying Grass Carpet uses
the familiar symbol of the Persian rug
to create a temporary shared urban
common in Essen, Germany

Overleaf: Crowds at a street performance
festival in Edmonton, Canada

Physical environment

Temporary events generally work with very low cost, highly mobile structures, where the emphasis is on flexibility and lightweight construction. Modular kit of parts structures, pop ups, inflatables and adaptable units are all frequently used, enabling swift construction, opportunities for customisation and easy transportation from one site to another. Where structures do have a fixed form (so are transported and placed as a single unit), they are either mobile or made up of lightweight 'frame and cladding' construction, enabling them to be installed and moved by a small number of people.

In contrast, most office design is permanent, heavily engineered and highly specified, with insufficient flexibility to adapt to change without time-consuming infrastructural alterations. Taking some lessons from the structures used in temporary public realm settings might help us to develop a much more agile and flexible working landscape with the capacity to respond to unpredictability and change.

Defining boundaries and thresholds is an important part of developing a sense of distinctive 'place' for many temporary urban events. The treatment of this threshold can set the tone for the rest of the experience, and curating the entrance to a space supports a feeling of destination, making it clear that the visitor has arrived somewhere distinctive rather than drifting passively through space.

In the workplace, the importance of thresholds and boundaries in creating a sense of territory is often undervalued. These zones can be viewed as the connective tissue of the office landscape, linking different spaces together while establishing their difference. Used effectively, boundaries can signal a changing event and offer visual cues about expectations of activity and behaviour. Many spaces in the workplace would benefit from a much clearer sense of transition between spaces; people intuitively expect to act differently when they recognise that they are leaving one space and entering another.

The furniture used in temporary public realm events is generally reconfigurable and lightweight, allowing visitors to arrange it according to their needs, or shared. The use of shared furniture creates a feeling of shared social space even where there is no active interaction between groups. Furniture may be integrated into elements in the wider landscape, such as seating that is an integral part of a raised floor surface. It may also be used to provide visual cues about how long you might expect to engage with a space, and whether you are permitted to rearrange it. These ideas are equally applicable in the workplace, where the furniture within a setting can signal and reinforce a whole spectrum of engagement, from short-term to longer term, and from passive to active.

Unless a place is so distinctive that it becomes a destination in its own right, there generally needs to be an offer — of food, products, services or entertainment — to encourage people to spend time there. This can be linked to social interaction, with people much more likely to linger in places where there is a multiple offer, providing them with everything that they need for a period of time. The relationship of these activities to one another is also significant; this is particularly noticeable for events like markets or distributed festivals, where people are not physically contained within a single space.

Left: Temporary events often rely on lightweight, modular structures that are easy to transport to site

Below: This Christmas market on London's South Bank transports complete units to the site to make the set-up as quick and easy as possible. Each stallholder can then customise their hut

Below: Spacebuster is an inflatable events space that packs away into the back of a van. The flexible proportions make it suitable for a wide variety of settings

Creating a design vocabulary

From our various field visits, we identified several broad design criteria — modular, customisable, standalone, defined, distinctive, flexible, low cost, and lightweight — that could be applied to rethinking workplace design. We used these criteria to develop a design vocabulary of urban realm elements with five categories in total: structures, orientation, boundary/threshold, identity/atmosphere and furniture.

This vocabulary deliberately shares some characteristics and crossover with the work in distilling the elements of theatre design. However there is an important point of difference — the stage design vocabulary focuses primarily on our personal and psychological relationship with space while the urban realm framework adds a layer that has more to do with how we physically interact with space in social and group situations. It addresses such factors as orientation, modes of occupation and place making, and one can recognise the importance to office design in exploring the five categories of the design vocabulary.

Although freestanding structures are commonly in use in the workplace — most often as small meeting or concentration 'pods' — they are almost universally heavy and immobile, with little ability to respond to changing needs or contexts other than simply being shifted into a new position. In contrast, temporary events utilise a wide range of adaptable, low cost structures; nine elements have been included here, each with different characteristics.

While most workplaces put a lot of thought into formal signage and wayfinding, there is significant room for development in terms of enabling people to make more intuitive decisions about where they need to go. Temporary events tend to do this very well, combining a range of techniques to allow people to make decisions based on a quick scan of the landscape; five orientation elements are included here.

Boundaries are an important element in developing a sense of place and signalling a shift in atmosphere and activity — both aspects that are generally overlooked in the workplace. Here we present two 'hard' and three 'soft' approaches to creating boundaries and thresholds.

We also include five design elements related to identity and atmosphere. Again, this aspect is often seen as an optional extra in the workplace and limited to tame visual exercises in company branding that do little to build company culture. In contrast, temporary event designers manage to do a lot with very little, creating distinctive, atmospheric settings that are comparatively inexpensive. The final category in the design vocabulary presents five furniture options that allow users to quickly and easily change their surroundings to suit their needs.

STRUCTURES

Inflatable structures are lightweight, easy to move and quick to install, making for very flexible short-term enclosures.

Movable structures are generally fixed dimensionally and should be lightweight enough to be shifted by only one or two people, allowing users to make constant short-term changes to their surroundings.

Pavilions are complete units that are dropped into the landscape and tend to be fixed in size and shape. Most existing workplace structures fall into this category.

Occupied surface describes a horizontal structure with a level change in relation to the surrounding area. They often include integrated furniture, making for a very direct kind of interaction with space.

Parasites attach to existing architecture, changing its use and form or creating supplementary spaces that complement surrounding activity.

Pop up/Expanding structures open out from a compressed starting point to create a larger enclosure.

Canopy structures create a feeling of enclosure but, being open sided, have no actual dimensional limitation.

Modular structures are made up of a kit of parts that should be easy to break down and move, making them quick to manipulate, adapt and install.

Screens are lightweight, temporary dividers that can be made of a wide variety of materials. They are often multipurpose, used for display or to reinforce identity as well as acting as partitions.

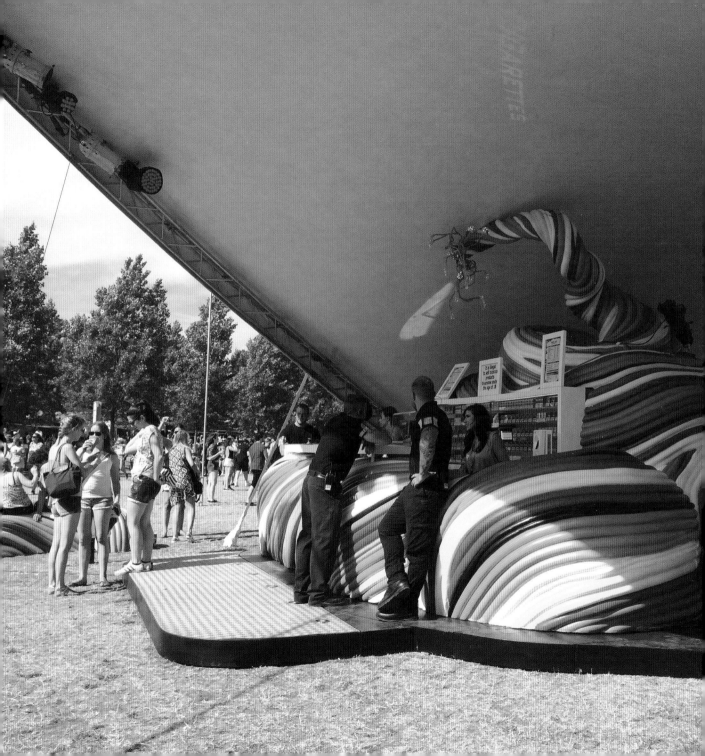

ORIENTATION

Pathways create direct links between spaces and people tend to instinctively follow them, whether they are a continuous strip of colour, or simply a series of markers.

Signposts should be strategically placed and not over used, providing people with clearly legible information about where they need to go.

Colour coding is used to create visual links between spaces or structures by using distinctive colouring to identify them, making them quickly and clearly recognisable at a distance.

Supergraphics are linked to establishing identity, but also have a role in orientation. They should be distinctive and clearly visible from a distance.

Landmarks can take a variety of forms, but are relatively large, distinctive structures that can be identified at a distance. They act as anchor points in a landscape, enabling people to consistently orient themselves relative to that large object.

BOUNDARY/THRESHOLD

Colour forms a soft boundary that can be reinforced by changes in lighting and furniture, indicating a shift from one activity to another.

Materials not only define the boundary but can change perceptions of expected behaviour; people will generally have different expectations of a space which has a hard wooden floor as opposed to soft carpeting.

Pattern/Texture is another soft boundary element that creates a clear textural difference between spaces, making for more distinctive and visually richer environments.

Archways define a clear entrance to a space and create a strong sense of arrival/destination.

Structural & Planted boundaries create a very clear delineation between one space and the next. They can range from solid boundaries that create a private enclosure to very light and open divisions, defining the extents without closing off a space. Planting has the additional benefit of introducing a softer natural element to what can be a very hard interior landscape.

IDENTITY / ATMOSPHERE

Colour is a simple and flexible way of developing atmosphere and identity. It can be introduced in the form of structures or simply surface applied, allowing it to be economically changed over time.

Graphics are linked to colour, but have more to do with applying pattern or typography to structures and surfaces.

Lighting is an important element in creating atmosphere, using colour, tone and intensity to create a widely varying range of effects.

Banners are generally lightweight and colourful and can be used vertically or horizontally.

Props & Signifiers support the creation of a setting. Props can provide an element of visual theatre by placing objects where you might not normally expect to find them. Signifiers are elements with embedded meaning, using specific associations to generate cues for use or subtly suggest settings.

FURNITURE

Shared furniture is used to create a feeling of shared social space even if people are not directly interacting, with long tables and bench style seating.

Movable furniture allows people to rearrange the space as groupings and activities change, and should be light enough to be easily moved by one person.

Reconfigurable furniture places the emphasis on pieces that fit together in different ways to create a variety of configurations according to need, inviting people to take an active role in arranging the space.

Touchdown furniture is designed for short-term use. It is generally relatively tall, keeping people vertical and discouraging them from getting comfortable enough to linger for long periods of time.

Integrated furniture is an integral part of a larger structure, whether it is a horizontal surface, a pavilion or part of a canopy.

Above: A board game style design prompt was developed to use in co-design workshops

Far right: An aerial dance troupe performing outside St Paul's Cathedral for the London 2012 Festival

Co-design workshops

Armed with our design vocabulary for the urban realm, we ran a series of six co-design workshops with 40 professionals in workplace planning and design to test the findings of the research. To manage this engagement, we created a board game called Deploy with each design element represented in a set of playing cards. Participants in the study were asked to use this tool to design their own settings around three scenarios related to group work or social settings in the workplace. At the end of the session, each group was asked to present their board back to the others, giving a brief explanation of their choices.

The results were instructive. There was general agreement that workplace settings would benefit from a greater ability to respond to changing needs and activities, whether by creating more adaptable settings or by providing more variety within the office, enabling staff to make a decision about where they would work best. There was particular interest in structures that could be moved or opened out to accommodate changing group sizes and configurations, or that would allow people to adjust the level of privacy and enclosure.

Orientation came up as an important theme. The idea of pathways that people could follow was popular as an alternative to standard physical signage, and a number of groups used the idea of colour coding to enable people to identify different spaces from a distance. Boundaries were seen as playing an important role in the definition of different settings, with clearly defined but open edges that allow people to flow in and out preferred overall. However, defining the edges with physical elements such as planting and the idea of marking entrances clearly using the archway element were also popular.

Generating a sense of identity and atmosphere was widely discussed, with design professionals identifying the importance of these elements in creating a sense of group identity and place. Colour and lighting were used most frequently, with many references to locally controllable lighting. Finally, movable, shared and

reconfigurable furniture were identified as currently missed opportunities in workplace provision.

What we learnt from the urban realm

The richness, spontaneity and unpredictability of many of the temporary urban events we witnessed — and the real connection they made with people — could not fail to strike a chord in relation to rethinking the workplace. Our investigation of design in the public realm added an additional and significant layer to the theatre design vocabulary. Although there are significant overlaps between them, particularly around lightweight, low cost settings and the principle of achieving maximum effect through minimum means, the overlay of a more flexible, temporal dimension adds something new in the quest to achieve truly effective and supportive workplaces.

Settings that are flexible over time or that allow users to have some input into their arrangement will require a new generation of workplace structures that take on characteristics like those found at temporary urban events. We found that markets and festivals offer an interesting urban planning angle on the mapping out of space, the marking of boundaries and territories, and methods of wayfinding. Meanwhile, pop ups and interventions are more discrete event settings that inform us about building relationships with and between people, and about creating specific and unusual experiences. All of this knowledge, extracted from some the most vibrant and colourful activities in the city, is required to bring our workplaces back to life.

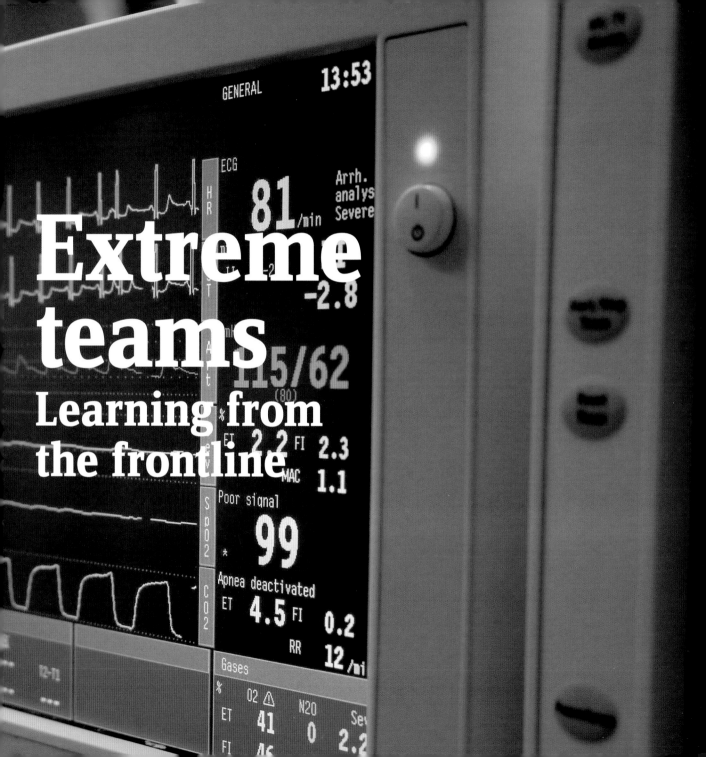

Extreme teams
Learning from the frontline

Learning from the frontline

With every second being critical, Formula 1 pit stops require highly coordinated and efficient teamwork to give the driver the best chance of success

Just as we would not equip a Formula 1 driver with a whip and a saddle, so we would not expect them to win the race on their own. There are few tasks at work that we can truly accomplish alone and, in the context of a rapidly changing, globalised economy, the problems that organisations now face are more complex than ever. The fast paced, knowledge centred work described earlier in this book increasingly requires us to draw on others for information and expertise in order to get the job done.

Jon Katzenbach, author of *The Wisdom of Teams*, observes: "There is virtually no environment in which teams — if done right — can't have a measurable impact on the performance of an organisation." Teams — if done right — can enable an organisation to make the best use of the collective knowledge held by its members, and are often critical in responding quickly to changing circumstances. Projects can run faster and more effectively; potential barriers can be identified more quickly. Sharing ideas within the team enables us to see problems from multiple points of view and to make new connections.

Team membership also has psychological benefits, with studies indicating that it is associated with greater enjoyment, job satisfaction and wellbeing.

Most organisations already recognise the value of teams. However the problem lies in exploiting their potential — in giving them the right settings in which to flourish. Unwarranted assumptions, long-standing habits and lack of systematic application of what we know about how teams function all too often hinder progress. 'Collaboration' can sometimes mean a back-to-back schedule of meetings with no clear goal; this saps energy, resources and morale.

If we are still getting teams wrong in the workplace, what could we learn from organisations that really get them right? This chapter is all about our collective processes — it investigates what enables us to work together effectively by researching teams for whom effective communication is essential. We spent time with air traffic controllers, accident and emergency medics and a daily television news team — all high pressure, high performance environments that depend to a critical extent on successful teamwork. We observed these 'extreme teams' at work and asked them questions about how they communicate, how processes are understood and shared, and the degree to which the physical environment is important. Our aim was to build up a picture of the fundamental components of effective teamwork.

What do we know?

The popularity of teams has tended to outstrip our knowledge about them. Outside of healthcare and air traffic control, detailed studies in organisational settings are still rare and multi-team working has been almost entirely neglected. The research that does exist reflects intense disagreements about what constitutes a team. This challenge is mirrored within organisations — we can not just label a group of people a team because the title sounds motivating and productive and then expect to see results.

The Katzenbach & Smith definition (1998) is a useful one, describing a team as "a small number of people with complementary skills who are committed to a common purpose, set of performance goals and approach for which they hold themselves mutually accountable". We can swap 'defined' for 'small' as companies are increasingly reliant on larger and more complex teams, but the principle still applies. This sounds simple but there are numerous examples of failure at all scales of business. Common errors causing teams to derail include giving them tasks that would be better done by individuals, not setting a clearly defined goal and including people within the team who are not really required. Where people end up in a team that holds little meaning for them, studies suggest that they are more likely to decrease their effort, which is hardly a desirable outcome (Karau & Williams, 1993; Mulvey, Veiga & Elsass, 1996).

There is a large body of research that tells us that factors including team composition, task design and team processes — such as setting goals and conflict resolution — do have an influence on whether or not teams are successful. Hackman (2002) defined four widely adopted prerequisites for teams to exist: first, team members are truly interdependent in the work that they do; second, there are clear membership boundaries — that is, everyone knows who is part of the team and therefore who shares collective responsibility; third, teams have specific authority to manage their work and relationships; and finally, team membership is relatively stable. Hackman also notes the importance of the task itself; it must be suited to teamwork and should be important, complex and challenging enough to require collective effort.

But even given all of this, teams in isolation do not equal high performance. This requires wider organisational systems — without an appropriate corporate culture in place it becomes more difficult to create successful collaboration. Successful teams need company-wide support systems, the reorganisation of structures — teams bounded by rigid hierarchies are more likely to fail — and high levels of resourcing (Sundstrom, 1999). This becomes increasingly important as teams grow in size. A decade or so ago, the general view was that teams rarely had more than 15–20 members. Today, however, complex tasks can involve much larger groups who may well be working across different locations. This can raise additional problems with communication, with a

tendency to split into smaller subgroups, but it is still possible for large teams to achieve high levels of co-operation.

Choosing our extreme teams

Our case studies were chosen as examples of high performance teams that could only function successfully by developing effective communication and teamwork processes. Air traffic controllers were our first port of call. After analysis of air traffic incidents found that failures in teamwork were a contributing factor, the role has been subjected to rigorous investigation into how teamwork can be improved. This is true throughout the entire aviation industry; the US-based National Transportation Safety Board found that 73 per cent of the incidents in its database occurred on a crew's first day of flying together, before people had been given the chance to learn through experience how best to operate as a team.

Teamwork is also hugely important in hospitals, where there are typically multiple care disciplines involved in looking after any one patient. Healthcare environments have also come under intense scrutiny – studies have indicated that healthcare professionals who work in an engaged and effective team report fewer cases of injury, error, harassment and abuse than those who are in what could be described as a 'pseudo' team (where they do not meet regularly to review performance or do not work closely together to meet shared objectives). Absenteeism is also lower in genuine teams, and there is a strong relationship between these healthcare teams and lower mortality rates. Our

third 'extreme team' came from the television newsroom, where we shadowed a daily news team. We chose this environment for the absolute reliance on communication and information transfer, with groups of people working in very different disciplines having to respond effectively to constantly changing inputs.

Air traffic control

The air traffic control team (or 'watch') at East Midlands Airport in the UK manages a combination of passenger, small recreation and freight aircraft, along with air ambulance services. Air traffic above 10,000 feet is controlled from a large central facility south of London; once it drops below this height, it is automatically transferred to the controllers at the plane's destination. The 'approach radar' controller – situated in a room at the base of the tower – is the first point of contact. They control the approach using a screen which has a 'strip' for each aircraft; these pop up in order in advance of planes coming under their control, giving the controller time to think about a logical landing plan.

The first contact with the pilot takes place when the aircraft is approximately 40 miles away, when the pilot radios in with their identity (or 'squawk') and direction. The controller gives the pilot their heading, routing them to predetermined beacons reporting points at which their heading can be adjusted. The radar controller turns the plane onto its final approach before handing over to the tower. The handover happens at approximately 2,000 feet. Although this is automatic, the two controllers also communicate via intercom. The tower controller has a 'slave' radar monitor; they can see

Our extreme teams included (from left to right): air traffic controllers at East Midlands Airport, A&E medics at St Mary's Hospital in London and a Sky daily news team

A simplified process map of the
procedures and interactions involved
in bringing a plane safely in to land

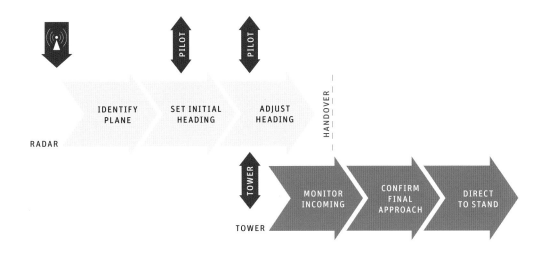

exactly what the radar controller is doing and are prepared in advance for the call. They can also see the airfield and have a direct intercom to the radar controller if they think that the flight plan needs to be adjusted in order to safely manage traffic. The tower controller then picks up radio contact with the pilot, directing them to taxi to the stand. If the radar is particularly busy, then this handover happens manually at an earlier stage — up to 6,000 feet from the ground — enabling them to split the workload more evenly. This relies entirely on verbal communication between the controllers.

Outgoing traffic is worked in a similar way, but starts under tower control before being transferred to radar. In the event of a non-standard event, there are various categories of emergency incident that are laid out in detail in advance, with a list of alerting actions and the people who need to be called. This hugely simplifies decision-making in an emergency situation, allowing the key team members to focus on managing the process.

Communication & information handover
The level of verbal communication is high in air traffic control. If it is busy then controllers sit next to each other and simply talk through what they are doing to address the workload. Handovers are also largely verbal; several minutes before the end of a session, the next controller plugs in alongside and watches. Once they have a sense of the traffic, there is a verbal handover and only when the new controller is happy will they switch places. The handover from one team to another is essentially the same, but can take up to half an hour to make sure that everything is running smoothly.

Eliminating misunderstandings is crucial — there is a book of standard phrases to leave no room for confusion. It is also as easy as possible to get in touch with team members who might need to be accessed quickly. The stations of different controllers are linked by an internal intercom and each desk has a customised communications screen that provides direct links to key contacts.

In terms of information management, the most critical factor is making sure that everyone is working from the same, most up-to-date information. The flight strips contain a letter code to tell the controller which weather information the pilot has accessed, so that they can check it is the same as theirs. Information is regularly updated. There is a whiteboard for daily notes and, at the beginning of each shift, each controller checks a file in the office for new notices which they then sign to confirm that they have seen it. Information transfer between different teams is managed through regular meetings of the watch supervisors who feed information back to their team. These are an opportunity to share best practice; if one team has developed an approach that works, it will feed into standard practice across the watches.

Working together

One controller told us that they "couldn't be in a more team-critical environment". This was reflected in every interview we conducted. The default position is 'defensive controlling'; even if only one position is open, a second controller will be watching to act as support if necessary. This may involve opening a second station, but can be as simple as acting as a second pair of eyes, helping the active controller to keep track of all information. The busier it gets, the more they rely on each other.

Various factors contribute to the high levels of trust in the watch. They have a strong sense of identity as a team, with common goals and a shared sense of the importance of their role. Stability of membership is important, enabling them to get to understand each other's 'quirks' and anticipate reactions. The stability of the team also contributes to a sense of community based on strong informal bonds. This sense of trust and teamwork is essentially built into their relationships from the outset; training is very much a mentoring process as trainee controllers operate on their instructor's licence.

Their approach to problems is also team based. There is an explicit 'no blame' culture; although people are expected to take responsibility for personal errors, the focus is on establishing the cause and working together to make sure that it does not happen again. They are also encouraged to develop an understanding of what external teams are facing. A number of the controllers have done crash simulations with pilots.

Environment

Access to information is critical in air traffic control; breaking concentration to find something could lead to dangerous mistakes. The workstations are standardised in terms of information layout, so that controllers can just sit down and work at any station

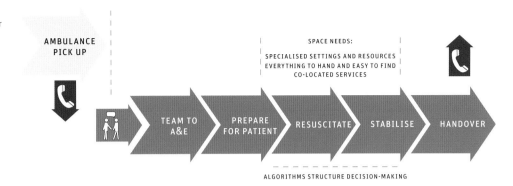

AMBULANCE PICK UP

SPACE NEEDS:
SPECIALISED SETTINGS AND RESOURCES
EVERYTHING TO HAND AND EASY TO FIND
CO-LOCATED SERVICES

TEAM TO A&E

PREPARE FOR PATIENT

RESUSCITATE

STABILISE

HANDOVER

ALGORITHMS STRUCTURE DECISION-MAKING

without having to orient themselves. This ability to just get on with the job is crucial: the space needs to be comfortable, with no distractions that might break their focus. Each controller has their own headset that acts as their licence – once it is plugged in, that station is automatically registered to them, eliminating time-consuming log in procedures. Breakout space is provided away from work areas, enabling controllers to rest and recuperate between periods of intense concentration. This was viewed as an important part of the workplace.

Accident & Emergency department

We spoke to medics and paramedics in the Accident & Emergency department (A&E) at St Mary's Hospital in London. There are two primary routes into emergency care. The first involves patients who have made their own way to A&E; the second is via the ambulance service. A&E receives a call from the ambulance to let them know that they are on their way and what to expect; this comes in via a special coloured phone that only the ambulance service has access to – one doctor said that "the only phone people answer quickly is that phone." The information is transferred to a handover sheet, which is handed to the trauma team; everyone on this team will immediately stop whatever they are doing and make their way to A&E.

The whole team will be waiting when the patient arrives. Whilst they are waiting, the senior doctor gives each person a clear role within that team, ensuring that they can immediately get on with what they

need to do, avoiding any confusion or duplication of effort. Every second is crucial when dealing with a critically ill patient, and the trauma response is highly process driven, with cascading protocols used to create a clear structure for decision-making. Essentially, where there is a decision to be made, the protocols tell the team what that decision is, removing delay in a fast-moving and stressful situation. From the emergency room, the patient will either be sent to the operating theatre or, once at a point of stability, will come under the care of the most relevant team for dealing with their problem.

Communication & information
The vast majority of the communication is verbal, whether that is in a trauma situation or dealing with patient referrals and handovers. A standard structure of communication enables doctors to process information efficiently. Verbal transfer allows the medic receiving the information to immediately question any omissions; this avoids wasting time with follow-ups.

Meetings are relatively infrequent and clearly structured – the most frequent are pre-surgery meetings. Again, the key processes are defined by established protocols. While the NHS (National Health Service) in the UK has several different systems in terms of information collection and transfer, it is still very reliant on handwritten notes. When a verbal handover does not take place, these are the primary means of transferring information. Scans and x-rays are transferred via a secure internal messaging systems.

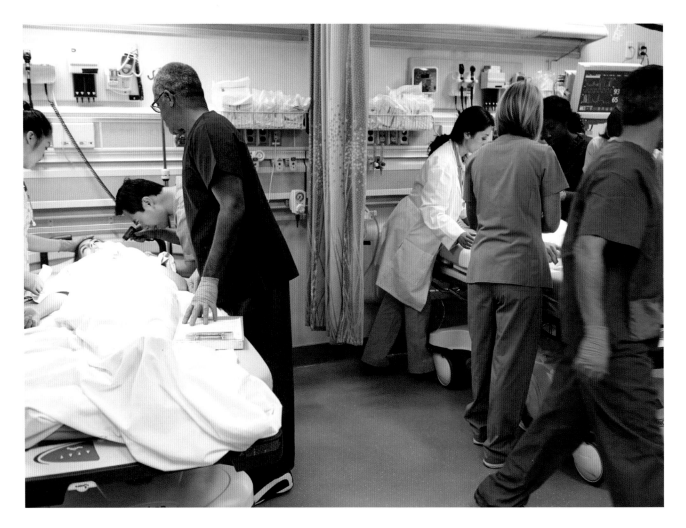

Working together

The A&E department of the hospital was identified as having a particularly strong sense of teamwork, especially when compared to the wards. Time spent together working on a clearly defined, shared goal was a major factor in this, rather than on the wards where the different care disciplines carry out their tasks more independently. In this sense, A&E was also felt to be less hierarchical, with a feeling that everyone's input was equally valued rather than a single person issuing instructions and expecting them to be followed. Stability of team membership was a factor, with A&E tending to have a higher number of more experienced nurses who stay in that role for longer, rather than ward staff who come and go more frequently.

A&E teams have clearly defined responsibilities to enable them to function quickly and efficiently within a tight space

Redesigning the ambulance

A design team led by Ed Matthews and Dale Harrow from the Helen Hamlyn Centre for Design and Vehicle Design departments at the Royal College of Art has been exploring the future of emergency mobile healthcare for a number of years. Its work has led to a new interior concept for the London ambulance that aims to improve paramedic teamwork.

In developing a fresh approach, the team used research methods that can be applied to the wider workplace to generate data about how teams use space. The researchers used Link Analysis (LA) and Hierarchical Task Analysis (HTA) to record what goes inside the ambulance treatment space – the equipment and consumables used, paramedic movements made and clinical procedures followed. LA is a way of recording and analysing physical movements, where links are defined as movements of position and communication. HTA is used to describe the detailed actions and sequence of events occurring within tasks.

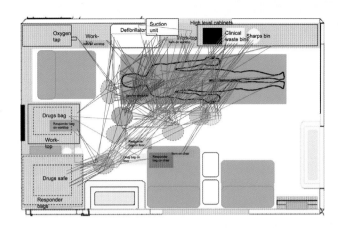

Top: Link Analysis mapping can be used to test the improvements made by different design interventions.

Below: Paramedics brought the existing London Ambulance to the Royal College of Art in London to talk about issues and areas for improvement.

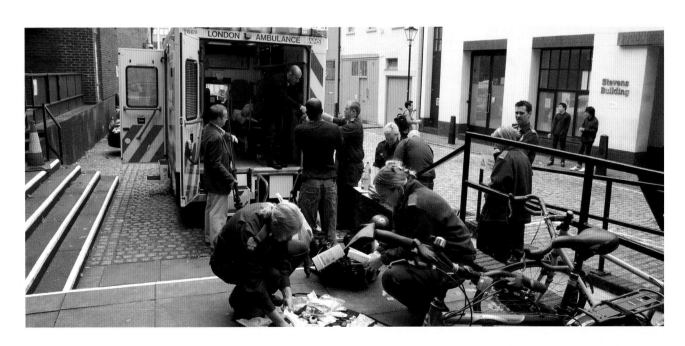

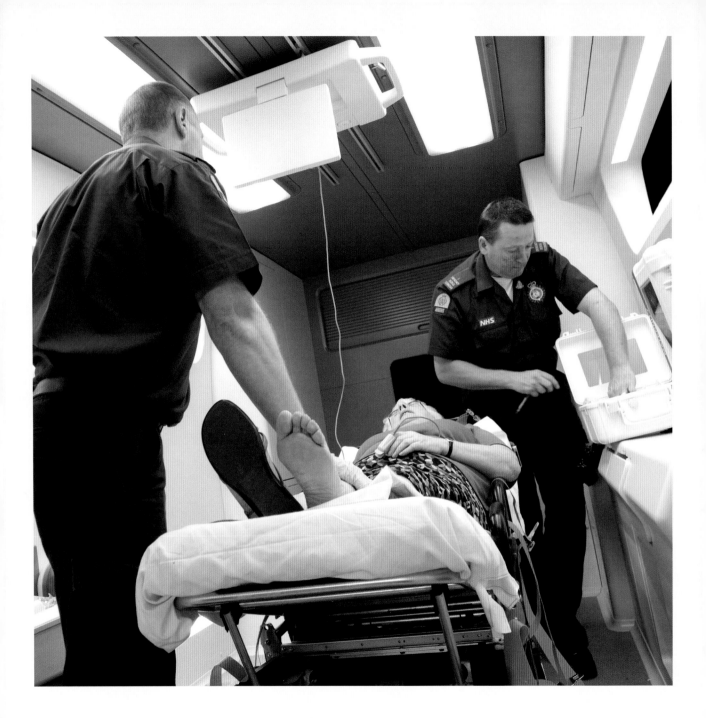

Findings from the two methods were combined with the results of interviews and ethnographic observation as the designers joined ambulance crews on callouts during 12-hour shifts. A full-scale test rig was mocked up in cardboard and foam. Six ambulance crews were then asked to run through their response to a simulated cardiac arrest within this rig; they were recorded with multi-directional video cameras and LA was again used to determine their working patterns. This allowed the design team to identify areas for improvement based on actual data and quickly model alternative approaches.

Frontline paramedics, clinicians, patients, academic researchers, engineers and designers worked together in this way to develop a full-size mobile demonstrator of the new ambulance interior. The redesigned patient treatment space gives 360-degree access to the patient, which improves clinical efficiency and enhances patient safety. The new interior is designed to be easier to clean. Modular equipment packs containing specific treatment consumables aid clinical performance, infection control and stock control. A new digital diagnostics and communications system was also developed part of this award-winning project.

Far Left: Paramedics at work in the new ambulance interior on a simulated emergency scenario

Top: Interior of the redesigned ambulance showing the central patient treatment space and easily accessible equipment packs

Left: The ambulance demonstrator unit parked outside the Royal Albert Hall in London

Media newsroom

We shadowed the team that produces the early evening news programmes at Sky, the satellite broadcaster. The senior producers meet early to set the day's agenda; when the news team arrives, they are allocated stories and correspondents. They check the latest updates before a team meeting at which ideas for treatments are discussed although each person 'owns' their piece, anyone can offer suggestions. The morning is spent sourcing footage, organising interviews, shaping the script and planning filming. This happens in collaboration with the correspondent who is often in a different location, so regular communication via phone, email and instant messaging is required.

Everyone works from a shared digital workstation that is constantly updated so that everyone can see who is working on what. Halfway through the day, there is an update meeting at which the producers are joined by the central news desk team, who update them on any new material. Also present are the editors for news programmes later in the evening so that the next shift can get a sense of the direction that stories are taking. A new agenda is printed and distributed, and the meeting is clearly structured and concise. At this point, the final order of news stories is decided so that each team member knows the timescale that they are working to and workload can be redistributed if anyone needs help.

The rest of the day is spent finalising material and editing pieces, with the picture editor and producer sitting next to each other to go through the story step by step. Centralised databases allow them to access footage from multiple external news agencies as well as from a dedicated internal department. The producer is also the point of contact with the graphics team. Requests are logged on the internal system, although they also meet quickly to talk through what they want to achieve.

Once the news piece is completed, it is uploaded to the gallery. The first bulletin goes out at five o'clock, then the team has the opportunity to get updates from the reporter and re-edit for the six o'clock edition of the news. A huge system of screens shows

Environment
Although the tasks are process-driven, the physical environment still has the potential to influence and even change the way people work. Poorly considered environments were identified as creating problems with efficiency and morale; one doctor commented that if people are working in a poor environment then "at best they are just keeping their heads above water". Well-designed spaces were identified as improving both morale and motivation, and also driving more efficiency into the system. A&E professionals spoke about the central importance of storage and standardisation; everything should be in the right place so that it can be found quickly and safely.

Top: Medical teams need all of the necessary tools and equipment to be easily accessible and to hand

Right: Simplified process map setting out the key stages in the day of a news producer

the gallery team what is currently on air, what is coming up next, and up to 16 external sources which can be fed in at any time; the system is set up to be both highly automated and highly responsive. The gallery team are in constant verbal contact with each other and in radio contact with the edit suites.

Communication & information handover
'Talking is everything' in the newsroom. Frequent and informal face-to-face communication is backed up by an internal instant messaging system called 'top line' which is always visible at the top of people's screen. Other than as a failsafe, email is very rarely used. Generally, the outputting of the news is very reliant on process; each piece is uploaded to a central system and the gallery cues it in. If there is a breaking story, it becomes entirely reliant on communication. As footage comes in, it will be 'hot rolled' — the producers will feed live footage to the gallery, and the executive producer will 'live feed' to the presenter, literally reading the script into their ear as they speak.

Clear points of contact are essential in managing the volume of information that comes in. The news desks act as points of contact for the correspondents and feed information on incoming stories

to the producers. With only a few hours to source guests each day, finding relevant contacts quickly is crucial. This is an important aspect of the shared workstations — past guests are all logged onto it and can be found easily using keyword searches.

Working together
What goes on screen for broadcast relies on everyone doing exactly the right thing at exactly the right time. The shared workstation avoids any duplication of work; it also means that if one person is waiting for material and can see that someone else's workload is high, they can jump in and help. The overall team is fairly stable. People become aware of each other's strengths and abilities, allowing them to establish their likely workload early in the day and limiting areas of potential stress.

Although people's roles differ — for example, there is very little overlap between the responsibilities of the picture editor and the correspondent — they have a clear sense of how they rely on each other to get the overall job done. Essentially, each role is clarified so precisely that the team is able to respond very quickly with the minimum of friction.

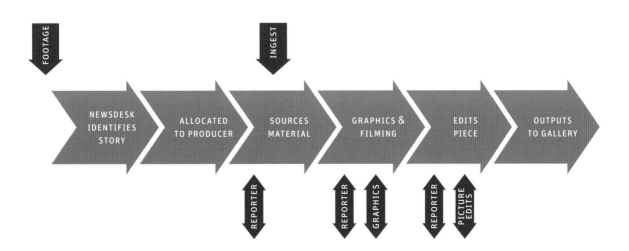

Environment

The most important factor in terms of space is having access to a range of dedicated settings that support highly specialised work. All of the tools required have to be in easy reach and all of the information on view. Most of the team stay in one location throughout the day to access specialised resources. However the producers are highly mobile – their priority is proximity to the people that they need to communicate with at that stage in the day. They start the day close to the editing suites and graphics room, with easy access to incoming information. By the end of the day, they move to a different desk adjacent to the gallery and news editors for ease of communication with the output team. The relationships between settings are also carefully considered, with clear functional adjacencies between linked activities or departments.

What we learnt

Although each extreme team was very different, we found common themes in all three areas – air traffic control, emergency medicine and television news.

Communication

Four key elements enabled teams to communicate effectively: the development of a common language, physical co-location, strong internal and external networks, and robust knowledge transfer systems. Each team shared a vocabulary in terms of acronyms and abbreviations and verbal communication was an important factor to limit misunderstandings. None of the three teams utilised email to any significant extent in their day to day work. It was used most

frequently at Sky, but this was generally to supplement another form of communication or to record ideas for later reference.

Verbal communication was strongly linked to physical proximity. At the airport, controllers who were actively working together would sit at adjacent positions, and the A&E team were generally occupying the same space during critical periods. At Sky, where teams were more distributed, they had short, structured meetings twice a day to update and debrief face to face in addition to actively seeking each other out as and when necessary. Consistently occupying the same space also encouraged the formation of social bonds and supported the sense of team identity — this was particularly the case in air traffic control.

All of the teams relied on strong internal and external networks. Internal networks meant that all team members knew what other people were doing, avoiding duplication of work and allowing them to support each other where necessary. The A&E and news teams were particularly dependent on being able to call on outside knowledge or expertise, and it was important that they were able to identify the people that they needed to talk to quickly and easily.

Knowledge transfer systems were also crucial. This includes customised and automated digital systems and the processes in place to manage information transfer from person to person. Digital systems were accessible to all and could often be added to by team members themselves, creating an ever-growing databank.

When meetings were held, they were structured and useful, timetabled with a clear goal in mind and sticking to a clear agenda. The air traffic control team also used meetings as an opportunity to be self-reflective about their processes, meaning new ideas could flow into wider practice.

Working Together
Shared goals and clear definition of responsibilities and objectives were essential in allowing each team to function effectively. Stable team membership and a sense of autonomy in how each member performed their work also emerged as important. All of this makes sense — it is difficult to form a community if you cannot all agree on what is important. Having clear objectives can also prevent the problem of 'over-collaboration' in organisations — people get stuck in a cycle of endless meetings and interesting discussions without ever reaching a conclusion or outcome.

Each team was clearly bounded in the sense that everyone knew who was part of it, who they needed to work with and what each member was doing. Even if the people directly interacting with each other changed on a daily basis, the overall stability of each team was important. They formed stronger bonds, were able to ask for help, and were able to anticipate each other's reactions. This is consistent with the findings of other researchers — sustainable collaboration is more likely to develop when people know and trust each other.

Each team had a designated leader, providing clarity on who was ultimately responsible for making decisions, but most of the work was self-led. This allowed team members to retain the sense that, although they were part of a wider unit, their individual contribution was important.

Workspace
The key factors in terms of the physical environment were access to resources, activity-based settings that supported specialised work, strong functional relationships between different settings, and the ability to dock down quickly to get on with work.

Having ready access to all of the necessary resources within their immediate workspace — whether tools, services or information — was crucial. Everything needed to be accessible and easy to find. Each team also had ready access to the wider range of services that they required in order to carry out their core functions. The teams required a range of specialised settings that actively supported the different facets of the work that they did. Each setting was tailored to specific needs, with systems and tools provided as appropriate. The provision of a range of spaces included rest or breakout spaces where they could regroup and refresh after busy periods.

The relationships between spaces were just as important as having the resources available. Related settings and services needed to have a strong physical link; overly long distances between frequently accessed spaces had a significant negative impact on the ability of medical teams to work efficiently. Sky did this particularly well, with carefully considered functional adjacencies between related activities.

With the potential for situations to change at a moment's notice, all three teams needed to be able to sit down and just get on with the job, with no distractions from the task at hand. Being able to dock down quickly was also important, with quick, straightforward log-ins and clearly structured information handovers.

A multi-faceted approach

Our study of extreme teams took in the broadest sweep of workplace interactions. What we learnt is that designing effectively for group processes will demand a multi-faceted approach throughout an organisation, with a coordinated effort to invest in the right resources, training and environments. Culturally, it will also require a paradigm shift for many companies, shifting the focus from individual accomplishment to team success. But given the inexorable rise of collaborative working to address complex problems, do organisations today have any real alternative?

Right: The Sky News gallery as the six o'clock broadcast goes out live. Multiple screens show the team exactly which information they have available at any time

Below: Edit suites are designed to provide all of the equipment that might be needed within a very compact space

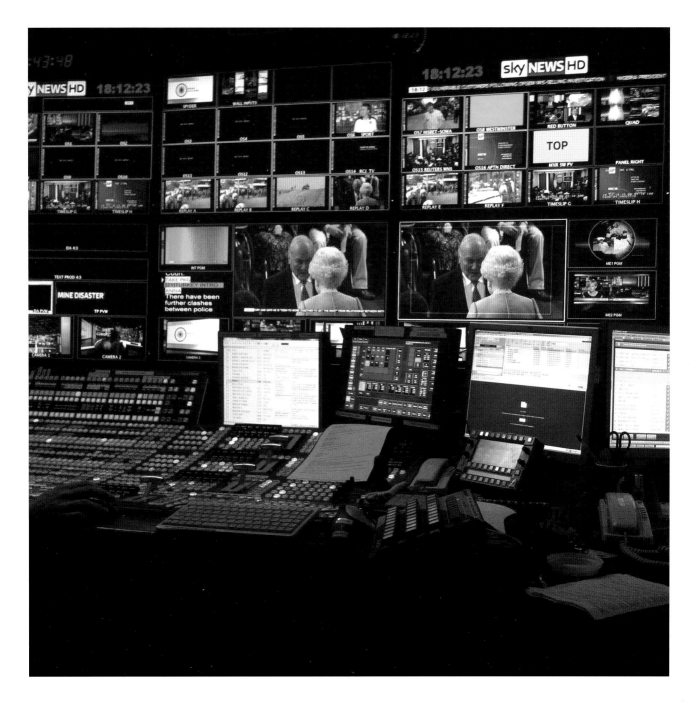

Framework for change
Learning a
new language

Learning a new language

Our journey through a range of different spaces and settings in search of new ideas to reinvigorate the office reminded us of that famous pronouncement by the American fiction writer William Gibson, who said: "The future is here – it's just not evenly distributed yet". Themes and approaches emerged during our investigations that appeared to offer ready application to the workplace from elsewhere. These ideas also offered the potential for the levels of depth, richness and connection that are currently missing in much office design practice.

The academic library research enabled us to explore in detail the processes involved in building and sharing knowledge – and the range of settings that may be required to support those processes. The theatre study was inspirational in providing ideas for psychologically and experientially enriched settings, without having to spend a fortune on bespoke design. Temporary urban events showed us how to create flexible and adaptable settings that support social interaction; and our research into extreme teams provided insights into the design strategies that high-performance groups or units require to be effective.

Although the four studies were distinct in terms of the areas we were drawing on, we discovered significant overlaps between the different types of environment and the design decisions on which they were based. The generic design criteria that came out of each study drew us to four key values that have informed the development of a new framework or model that aims to address the relationship between process and experience in a more balanced way to create workspaces that are fit for the twenty-first century knowledge economy. We have termed these values *flexible, legible, experiential* and *comfortable*; collectively, they form an approach we have named the FLEX model.

The first value is flexibility, requiring us to think about designing more flexible settings that can be tuned to different short-term needs and can adapt more easily to changing and unpredictable requirements over time. The second value is legibility – legible environments are more easily and intuitively 'read' by their users, and incorporate visual cues to make that happen. The third value relates to experience – experiential spaces are designed as complete

environments, projecting atmosphere and mood and enhancing culture. The fourth value is comfort — a comfortable workspace is one in which employees feel welcome, relaxed and supported in the work that they are trying to do. Flexible, legible, experiential and comfortable — let us have a closer look at the FLEX model.

Flexible

We have become accustomed to a world of choice in our everyday lives outside work, but most of us still labour in offices that are static, inflexible and expensive to change, with little capacity to offer users any level of autonomy. In contrast, academic libraries increasingly offer a wide variety of settings, tuned to different activities and needs; theatre designs and temporary urban events are similarly a rich source of inspiration in exploring solutions that allow space to respond much more flexibly to change, and the best 'extreme team' environments provide people with a range of settings that support the various tasks they need to perform. Flexible workplaces give people a choice about where they think

they will work best, providing a blend of task-specific and more adaptable settings that will support different modes of activity. They also provide settings that are able to respond more efficiently to changing organisational needs, using modular elements that are independent of the architecture and can thus adapt much more quickly to change than existing workplace solutions. Flexible spaces also allow users a level of control over their environment. Our studies found that, in many offices, the only thing that people feel they can influence is the height of their chair. Providing environments that allow users to tune them to their needs and preferences is not a luxury — it is a necessary part of providing workplaces in which people feel invested.

Above: A simple movable screen lets people control the level of privacy in a soft seating area. Concept by Imogen Privett

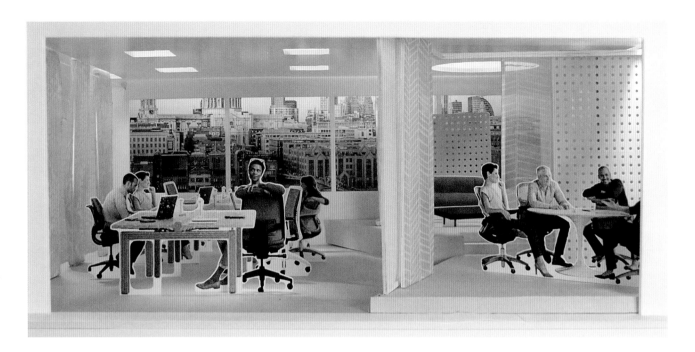

Above: Concept by Imogen Privett
showing clearly defined areas
supporting different kinds of activity
without the need for permanent
structural divisions. Lightweight top
hung screens and subtle graphics give
the overall space a sense of identity,
and flexible partitions allow groups to
divide the space up as necessary

Responsive and standalone

The central idea at the heart of scenography is that the set should be able to adapt and respond to the action, rather than being a static element of decor. Similarly, workspace settings need to be able to adapt and change to cope with the evolving needs of the 'players' in any organisational scenario. It should be possible to scale spaces up or down, so that they can accommodate different numbers of people and changing functions. Adaptable furniture and a wider variety of partitioning and screening could help to achieve greater flexibility.

This is not to say that the entire space has to be adaptable — these flexible elements can be combined with fixed 'anchor' points, providing a balance between change and continuity. Event Box from the academic libraries study is a good example of this. The presentation wall is fixed, while the hanging screens provide an adjustable boundary and the furniture can be easily reconfigured to suit a range of requirements. We also developed settings during the theatre study that used a blend of larger scale, architectural pieces and flexible, adaptable screens.

Settings can adapt far more swiftly than a building can and are a more economical way to effect organisational change. They should therefore be thought of as architecturally independent — a layer that sits lightly within the existing structure and can be easily rearranged to suit a variety of different situations. Temporary urban events are particularly good at this, using architecturally independent components that maximise flexibility and allow them to be moved, packed away or reconfigured according to need, whether from day to day or over a period of months.

Low cost and lightweight

Both temporary urban events and theatre designers manage to create high impact spaces working within tight budgetary constraints. They are inventive in their use of materials and economical in their construction methods, often taking the approach to design that we identified in the theatre study as 'maximum effect through minimal means'. This design approach offers workplaces a way to achieve higher impact spaces without having to invest heavily in spaces that might become redundant as organisational needs change.

The weight of the elements that make up an event or theatre production setting is a major consideration when all of the pieces have to be transported to site and set up quickly, often with minimum manpower. By contrast, existing workplace solutions tend to be heavy and immobile — most workplace furniture is too heavy to be moved easily, sometimes requiring several people to move one bench. We need to explore lightweight solutions that are movable by only one or two people, without any special equipment or forward planning. For example, the Canopy concept in the libraries study was designed to be lightweight and mobile, allowing people to make easy, short-term changes to their surroundings.

Modular

Both stage design and urban events rely heavily on ease of transportation, storage and installation, resulting in a strong emphasis on modular structures and components that can be quickly fitted together in a variety of configurations. This allows for responsive and adaptable settings that can be reconfigured over time. Modularity can either apply as a method of construction (allowing pieces to be broken down and re-formed as necessary), or as a way of allowing for a wide variety of configurations to be formed from a limited palette. Larger scaled pieces currently tend to be custom made, requiring a significant financial commitment. During the theatre study, we looked at ways of making them with a more economical kit of parts approach that would allow for a variety of standard configurations.

Customisable and tuneable

When we explored environments that frequently use standardised components, we could see that the outcomes in each case were very different. The ability to quickly and easily customise these components to reflect the identity and aspirations of a specific event or stage production was always crucial, whether by applying graphics or by using colour, materials, composition and texture to change their appearance. As supporting cultures and group identities at a variety of scales within the workplace becomes ever more important, this ability to personalise settings in some way and give users ownership of their surroundings will be key. Customisation can also extend to smaller, day to day fine tuning to meet particular needs.

An employee's ability to affect their surroundings has a significant impact on their productivity — as identified by various researchers — and spaces should be designed to allow people to tune them to suit their personal preference, either by increasing levels of privacy, reducing noise, altering the light, choosing imagery and accessories, or by moving furniture. These are all small scale changes, which should be achievable quickly and intuitively, enabling change from day to day. This ability to 'own' your environment — even if only in very simple ways — is also a major component of the sense of psychological comfort identified in earlier chapters of this book. This sense of ownership applies both to individual and to group workspaces.

Legible

We have all seen offices in which people are faced with a sea of open plan desks, rows of identical offices and meeting rooms, and signage that can only be clearly read when you get close to it. In an environment that offers greater choice and flexibility, the options need to be clear and people should be able to navigate the workplace more easily and intuitively.

Left: Changes in floor finish define different zones and create clear pathways. Boundaries can be either 'soft' or 'hard', with architectural elements framing different areas. Here, the frame creates a sense of division, but the two spaces remain visually connected. High level banners or screens can be seen from across the office, making the location clear and making the space easy to read from a distance. Concept by Imogen Privett

Right: The experiential aspects of a space should support the activity that takes place there. In this concept by Imogen Privett, a change of light level and colour creates a quiet, calm atmosphere that is clearly different to the brighter lit areas around it. Lightweight, non-structural columns provide an opportunity to introduce colour and texture, and changes in both level and floor finish create a sense of transition into the space

Intelligent landscaping

This aspect covers the thoughtful development of the relationships between settings and activities, provision of a range of environments that relate to the various tasks being performed and ease of movement around the space. It might seem too obvious to get wrong, but many employees still work in environments where they are physically distant from the people or services that they need to access regularly, or they simply do not have the workspace required for what they are trying to do. Knowing where to find what you need, having settings appropriate to the task and minimising journey time between work settings were all particularly important in helping teams to work together more effectively. Thinking carefully about the relationship between different spaces can also be used to intensify occupation; for example, locating a coffee-making bay near an informal meeting area can help to foster social activity.

Wayfinding

Temporary event designers are very good at allowing people to make intuitive decisions about where to go, and many of the same techniques could be employed in the workplace where repeating

floorplates can disorient building occupants. Combining smaller-scale signposting with clear visual landmarks so that people can quickly pick out where they need to go enables them to make quick decisions during the working day. Larger scale signage, graphics or structures that are visually distinct also enable people to quickly locate themselves relative to that object, retaining a sense of where they are in the overall space — particularly useful on a large or deep plan office floor. Colour, pattern, materials and structures can also create visual links between spaces that are similar across the wider floorplate, so that people can pick out what they are looking for.

Place making

Place making is a familiar concept to urban designers. It is often seen as the difference between a beautifully designed but empty space and one that is actively used and enjoyed by people. The interaction between people and their environment is key when it comes to 'making places'; thinking about the simple elements that will actually make a space work for its users should become a more robust feature of the workplace design process. A sense of ownership is also important. The most successful social spaces in the urban realm tend to be those that actively encourage people to

play a role in the evolution of that space. This requires a much more user-led understanding of place and has significant implications for the way that workplace is generally developed. Traditionally, decisions about workspace are made by a small group of 'experts' and the installation is viewed more or less as the final iteration of the space. We need to develop much more effective dialogues with the end users of a space, not just between design professionals and senior managers.

Boundaries
Boundaries are an important element in developing a sense of place and in establishing difference between settings. Clearly defining the edges of a space encourages a sense of transition that is important in creating legible workspaces, making the different options clear. Boundaries also help to indicate the function of a space, signalling expectations of a change in activity and behaviour; for example, cool colours, dark furniture and high partitions suggest a quieter space for concentrated activity. Structural boundaries can range from lightweight screens to full enclosures, but they can also be

created using changes in level, colour, lighting, acoustics, floor surface and furniture. We explored this in a number of our design studies, using both hard and soft boundaries to define the limits of a space, to make the relationship to the surrounding areas clear, and to control movement and circulation.

Framing, vista and layers
Framing, vista and layers are all to do with the fundamental shaping of space, creating visual interest, a sense of spatial diversity and 'pause points' that arrest the gaze and give people time to register different settings and modes of activity. Many workplaces only operate on three horizontal planes (floor, desk surface and ceiling) and two vertical ones (full height walls and desk screens) and simply do not provide this kind of visual input. Framing and vista are about controlling views to strengthen a sense of spatial narrative, to create a sense of journey or discovery, and to support the definition of boundaries and edges. Layers can be used to create depth, making it easier for people to locate themselves.

Applying the FLEX model

The FLEX framework points to the development of workplace settings that are more flexible over time, allow users to have some input into their arrangement and incorporate structures that are more mobile and lightweight than traditional office kit. In an extension of our study, Tom Jarvis, an industrial designer and researcher based at the Royal College of Art, took some of our findings to develop new product concepts capable of articulating and testing this new design vocabulary.

Jarvis identified the combination of light and surface as a missed opportunity in current product development — light cannot exist without surface and yet the two are rarely developed together. This became his main area of focus and he explored different qualities of surface such as colour, texture and translucency and how they interplay with light.

Jarvis applied this alternative approach to the suspended ceiling, a visually dominant expanse of space in most offices that is used to house light fittings and hide cabling. He wanted to explore whether we could exploit this underused, unrelenting space to create opportunities for user control, increase visual interest and provide a sense of privacy, while remaining true to the FLEX criteria.

Taking early inspiration from theatre flats, he decided to focus on top hung screens, which have rarely been explored in the workplace in any systematic way. He developed a simple prototype system that could be used to break up the suspended ceiling and create temporary partitions in open plan space. In addition to offering a wide range of options in terms of materiality, texture and colour, the system was designed to be low cost, lightweight, modular and quick and easy to set up.

The screens were attached to the existing ceiling grid using magnets and arranged to fold out from the ceiling tile in a variety of ways and at different heights from the floor, creating partitions, meeting enclosures or simply ceiling hung clusters that provide a level of visual landscaping and variety.

The research team tested the prototype screens that Tom Jarvis developed in three different UK offices, including a newly renovated space and an older office that was due an overhaul. Trials focused on two scenarios: individual concentration, providing people with the opportunity to seek privacy and reshape their space, and collaborative work, allowing teams to change the feel and function of communal areas.

Test screens were made of paper to enable us to produce a wide variety of low cost options, and were installed in each office from three to five days, with employees invited to actively use them and report back. This enabled us to go through a systematic feedback process to develop a rich bank of insights based on observations, reactions and conversations. We tested responses to warm or cool colours, open or closed structures, bright or subdued lighting, and translucent or opaque surfaces.

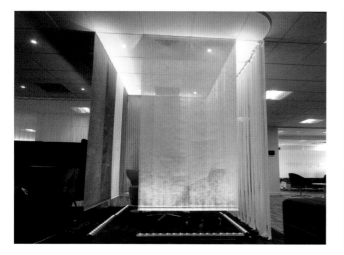

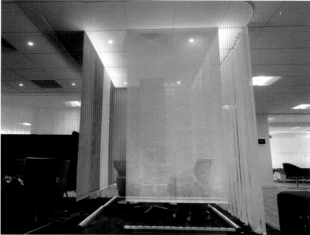

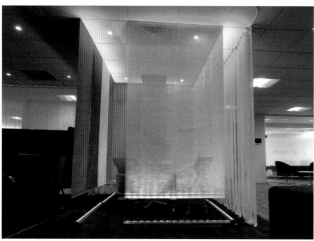

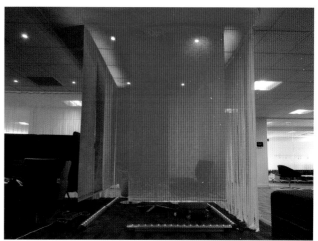

The insights gathered were used to inform the design of a more fully realised product prototype that will be jointly developed by our industrial partners, Haworth and Philips Lighting. One of the key aims of the exercise was to demonstrate that by taking just a couple of the variables identified in the FLEX framework, designers are able to imagine a whole new world of work.

Left: The testing rig was designed to allow us to quickly create flexible partitions

Above: LED lighting can provide dramatically different effects and environments, with the potential for users to affect their surroundings on a daily basis

Experiential

The importance of experience within the office environment has been a central pillar of our thinking throughout this book, and it could be argued that this aspect has received least attention in the modern workplace. We place huge emphasis on ergonomics, function and process – and pay far too little regard to our psychological interactions with space. 'Vanilla solutions' may offend nobody, but they do very little to make settings distinctive, enhance organisational culture, or develop a shared sense of identity on the group level that psychologists suggest is most important.

The theatre sets and temporary urban events in particular provided rich sources of inspiration in how to create expressive, distinctive and engaging spaces using deceptively simple techniques. Scale, texture, translucency, light and colour all feed into the creation of spaces with the visual qualities that allow people to develop a level of attachment to their surroundings.

Distinctiveness
This aspect is linked to place making and the importance of giving each setting a distinct identity. It is often the difference between an inviting setting that will draw someone in, and a space that is unappreciated and underused. In particular, breakout and social spaces can be undifferentiated from the rest of the office. The principle should be to create an appealing and interesting landscape of spaces within the office, with a visual identity that embeds cues for use into the space. Distinctive environments should be complete habitats, not simply a collection of objects, with thought given to colour, texture, lighting, furniture, props and boundaries. Props – as used by theatre and event designers – do not have to be large or flashy. They can be subtle additions to the space that support the overall experience and atmosphere and generate intuitive cues for reading the space.

Light and shadow
Lighting is fundamental to theatre and event design; without it, even the most beautifully designed setting can appear flat and dull. This is more or the less the condition facing us in most

workplaces, where ceiling-mounted luminaires cast a uniform field of light that, at worst, can create a feeling akin to snow blindness. There is huge unexplored potential for using lighting to create atmosphere – this needs to be an integral part of the design of a setting, tailored to the mood and activity that needs to be supported.

This approach requires a rethink of the way in which offices are planned and designed. By the time the average speculative office development has been let to a tenant, the lighting grid has been installed and there is no flexibility for change short of physically removing fittings. However the existing grid system could be developed with more inbuilt flexibility and there is no reason why light cannot be more thoughtfully used as a standalone layer to enhance workspace design schemes. There are real opportunities to use light to introduce pattern, shadow, texture and colour in a user-controlled, flexible way. Lighting tone can also be changed to support different modes of work; cool blue light tends to support concentrated activity while warmer tones create a more intimate, informal feel.

Texture and scale
A major complaint raised during our co-design workshops with architects and designers was that workplace surfaces tend to be uniformly smooth and flat, with very little textural variation. Texture is often overlooked as a way to add variety and richness without having to use too many different colours or patterns. It could be applied by using different surface materials, but might also be created by using light and shadow, which provides great flexibility and variation. The same texture can also be used at different scales – playing with scale, whether architecturally or graphically, is a very simple way of adding visual interest.

Colour and translucency
A move away from vanilla solutions is well overdue. This does not mean a wholesale switch to a multi-coloured workplace, but colour can play a more significant role in developing the identity of a space. This could mean a multi-tonal, saturated space, but could equally refer to settings that use light washes and subtle colour palettes to

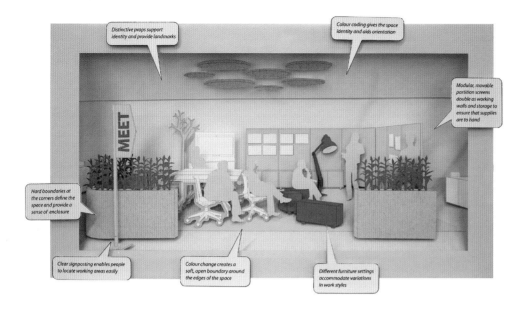

A combination of fixed and flexible elements means that the boundaries are defined, while still allowing users to fine-tune the space to suit their needs. Integrated storage and working walls mean that tools and resources are all to hand. Concept by Imogen Privett

create interest without schemes becoming overwhelming. Colour also has a strong relationship with light; light gives it vibrancy and can create varying tones through the course of a day. New lighting technologies provide us with the opportunity to apply colour as light, creating endlessly changeable effects.

Using layers or changes in translucency — both in colour and materials — is very important in theatre design and often entirely lacking in the workplace, where materials tend to be either wholly solid or transparent. Using translucent or perforated materials came up frequently during the co-design workshops we held as part the theatre study; this was seen as a way of building up different layers of visibility, retaining an awareness of occupation and activity without revealing everything at once.

Comfortable

Our workplaces need to be flexible, legible and expressive enough to adapt to changing needs and preferences so that workers will find them physically and psychologically comfortable to use. However, while we believe these three criteria are critically

important, we are also aware that they are not sufficient on their own — even the most adaptable, understandable or atmospheric spaces will fail if they are not welcoming and easy to use. In essence, comfort is all about providing settings and systems that minimise distractions and allow people to focus on the task at hand. Flexible, legible and experiential aspects of design all assist in making workplaces that can be classified as comfortable — but the concept of comfort in its truest form goes further.

Welcoming
Psychological comfort, as defined by Jacqueline Vischer in Chapter 1 of this book, goes beyond having an ergonomically designed desk and chair, the correct lighting levels or the right temperature. It is all about making the office environment more human, welcoming and personal, with spaces that draw people together and actively support them in the work they are trying to do. The concept of comfort encompasses the physical design of settings, but also the underlying systems that support them. Comfortable work settings are task oriented, with all of the required tools easy to find and to hand. We found that this was a critical factor in enabling people to work effectively in high-performance teams.

Easy

Comfort is linked to the ability to dock down quickly and get on with work. If people are using their own devices, then connecting to the wider network must be quick and easy. Shared desking should be comfortable, easy to configure and have clear protocols of use. This also applies to group and collaborative spaces, where systems for booking spaces (if required) should be transparent and straightforward to access. The Smart Study concept developed during the libraries study expressed some of these ideas, allowing people to automatically adjust a space to suit their own preferences.

Supportive

The value of comfort within our FLEX model also encompasses management styles and systems and the degree to which people feel supported in their ability to do their job. A clear, shared goal was identified as a crucial component of effective teamwork.

In Conclusion

Our FLEX model is a framework for change for the twenty-first century knowledge-driven workplace. It proposes that more flexible, legible, experiential and comfortable workspace design can address the central dilemma we pinpointed at the start of this book. This is that poorly considered office design inhibits the development of positive and progressive organisational cultures just as much as good office design supports them.

The FLEX model allows knowledge communities to flex and build; its principles support psychological comfort and emotional wellbeing among workers, fostering a sense of identity and belonging; it provides clearly defined territories and cues for group use to help teams flourish; it affords more user choice and control and stimulates greater social interaction; its emphasis on comfort creates personal satisfaction with and attachment to the work environment — and this feeds back into job satisfaction, loyalty to the employer and a cycle of formation of a positive culture at group and organisational level.

The FLEX model challenges existing ways of doing things in workplace design, in particular the procurement of developer-driven offices that have little or no inbuilt flexibility, the tendency to treat real user input into workspace planning as tangential rather than critical to success, and the timid reliance on established office design archetypes (desks, benches and so on) in developing new products. It proposes a more integrated and holistic approach in which the demands of process (what people do the workplace) and experience (how they feel about it) are balanced more effectively.

The principles of the FLEX model are deliberately broad, generic and non-prescriptive, so that each team of architects, designers, developers, managers and clients can work it out in their own way and on their own terms. As researchers, we have been on a journey through different places, spaces and systems, drawing insights and ideas from a diverse array of human interactions with the built environment along the way. That journey does not stop here. As Ernest Hemmingway once wrote: "It is good to have an end to journey toward; but it is the journey that matters, in the end."

We suspect that readers of this book will want to make their own journey and draw their own conclusions. That, in the end, is the most important thing if we really want to improve the human and social dynamics of our future work environments.

Right and overleaf: Industrial designer Tom Jarvis of the Royal College of Art conducts user research with a paper prototype of his top hung enclosure system at the Haworth showroom in London

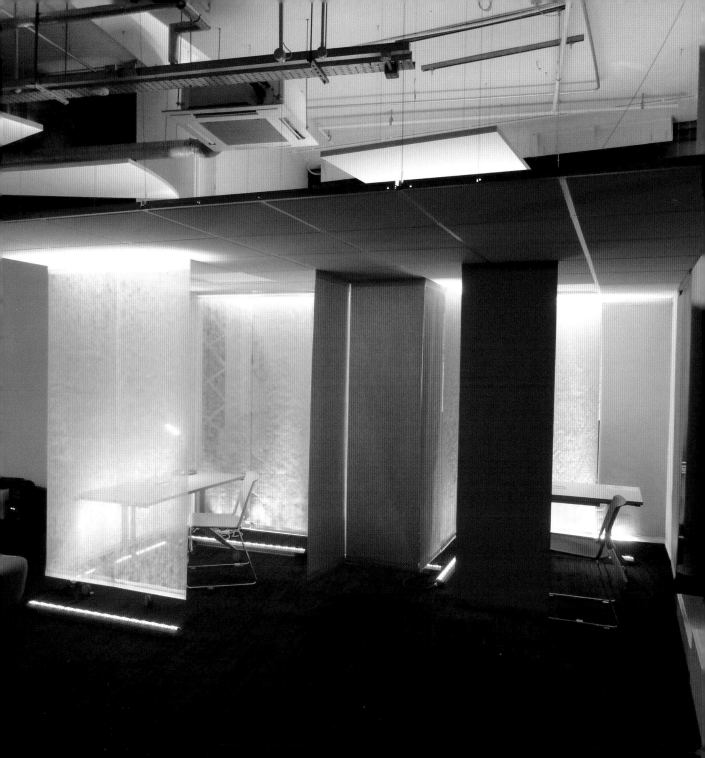

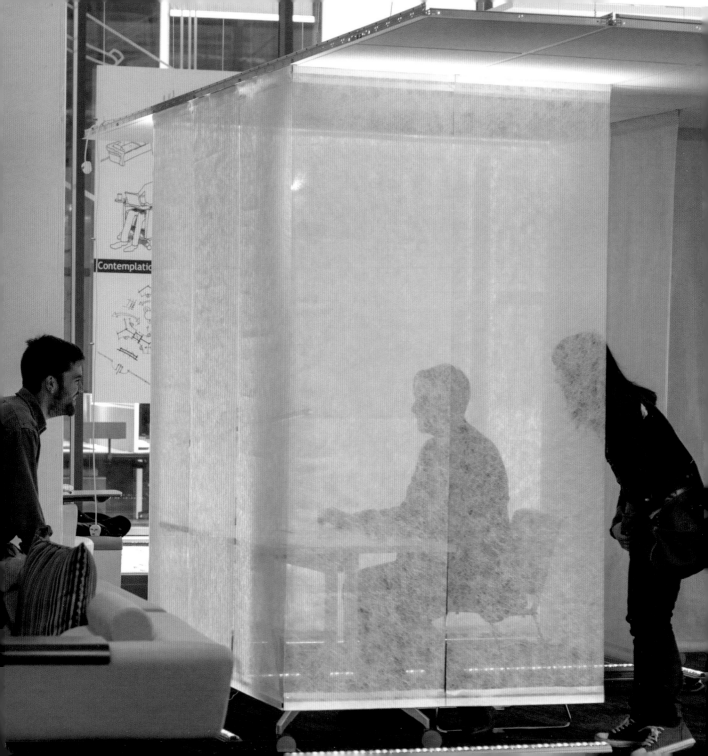

HAWORTH®

PHILIPS

A shared philosophy

Building the culture of organisations matters greatly to all who plan, design and manage our workplaces.

Getting the environment right to enable a positive culture to flourish is key to maximising investment in new office design. Haworth and Philips Lighting share a design philosophy that is based on building a detailed understanding of how the interplay of light, space, settings, furniture, systems and people can contribute to a better workplace.

That is why we supported the publication of *Life of Work* – and why we commissioned the original research studies from the Helen Hamlyn Centre for Design at the Royal College of Art on which this book is based.

What does *Life of Work* tell us?

It tells us that a balance in approach is needed between what people do at work and how they feel about it.

It reminds us that there are so many places and spaces, ideas and approaches outside the office that can inform, inspire and enrich design within it.

It goes broad in exploring such over-arching themes as social interaction, knowledge generation, modes of communication and decision-making – and goes deep in examining such practical

issues as framing and vista, shadow and light, modularity and materials, structures and signage.

Ultimately it equips us with a new model for thinking about workspace in order to provide greater flexibility and comfort as well as an enhanced experience that is intuitive and easy to understand.

At Haworth and Philips Lighting, our design and development teams are endlessly curious about changes in the world of work and eager for new knowledge that will help us respond in a way that will enhance organisational culture.

Life of Work provides a useful building block in our development of new products, settings and systems for the future world of work. We hope you enjoy reading it as much as we have enjoyed being part of the research journey.

Francois Brounais
Haworth

Menno Kleingeld
Philips Lighting

Index

Authors

Jeremy Myerson is co-founder and director of the Helen Hamlyn Centre for Design at the Royal College of Art, London, where he is a research professor and the first ever holder of the Helen Hamlyn Chair of Design. An author, academic and activist in design and innovation, he has written widely on workplace design and chairs the international Work Tech conference series. His many books include *The 21st Century Office*, *The Creative Office*, *New Demographics New Workspace* and *Time & Motion: Redefining Working Life*. He sits on the advisory boards of leading design schools in Korea and Hong Kong, and holds arts degrees from the Royal College of Art and the University of Hull.

Imogen Privett is an architectural designer and researcher. She graduated with a Masters degree in Architecture from the Royal College of Art in 2011 and joined the Helen Hamlyn Centre for Design as a research associate in its Work & City Research Lab. With a background in workplace and education design, Imogen has worked with leading architectural practices Pringle Brandon Perkins + Will and Surface to Air. She holds undergraduate degrees in Architecture from the University of Westminster, and in History from the University of Cambridge.

Acknowledgments

The authors would like to thank our research partners Haworth and Philips Lighting for their support and encouragement throughout the research and writing of this book, with particular thanks to Francois Brounais, Jackie Bergonzi and Mark Bridgman at Haworth and Menno Kleingeld and Claire Phillips at Philips Lighting. Special thanks also to Margaret Durkan for picture research and Catherine Greene of the Helen Hamlyn Centre for Design at the RCA who laid the groundwork for the entire project with her study of academic libraries. Catherine was central in defining the landscape of our research, and the drama department at the University of Hull should also receive credit for stimulating our interest in the modernist pioneers of theatre design.

The work of Dr Craig Knight and Dr Jacqueline Vischer was key to informing the development of our central thesis, and we would also like to thank the many other experts who gave us the benefit of their time and expertise. These include Sarah Beaton, Peter Bishop, Stephen Block, Pringle Brandon Perkins + Will, Aedas, Andrew Harrison, Nadine Spencer at The Collective, Imperial College Library, the Open University and all of the architects and designers who took part in our co-design workshops. Finally, we would like to thank Duncan McCorquodale, Kate Trant, Amy Cooper-Wright and Matt Boxall at Black Dog Publishing for bringing *Life of Work* to life.

References

Introduction

Elsbach, K, Bechky, B.A, 'It's more than a desk: Working smarter through leveraged office design', *California Management Review*, 49 (2), 2007, pp. 80 – 99

Freeman, K, & Knight, C, 'Enrich your office and engage your staff: Why lean is mean', *Ambius White Paper*, July 2009. [Accessed 05 Feb 2012]. Available at: http://www.ambius.co.uk/biophilia/downloads/why_lean_is_mean.pdf

Haslam, S.A, & Knight, C, 'Cubicle, Sweet Cubicle', *Scientific American Mind*, September - October 2010, pp. 30–35

Haslam, S.A, & Knight, C, 'The relative merits of lean, enriched and empowered offices: An experimental examination of the impact of workplace management strategies on well-being and productivity', *Journal of Environmental Psychology*, 16 (2), 2010, pp. 158–172

Humphry, J, 'Mess or nest: do clean desk policies really help us work better?', *The Conversation*. [Accessed 09 Feb 2012]. Available at: http://theconversation.com/mess-or-nest-do-clean-desk-policies-really-help-us-work-better-3037

Knight, C & Haslam, A, 'Your place or mine? Organisational identification and comfort as mediators of relationships between the managerial control of workspace and employees' satisfaction and wellbeing', *British Journal of Management*, 21, 2010, pp. 717–735

Sundstrom, E, *Work Place: The Psychology of the Physical Environment in Offices and Factories*, Cambridge: Cambridge University Press, 1986

Veitch, J.A, Charles, K.E, Farley, K.M.J, & Newsham, G.R, 'A model of satisfaction with open plan office condition: COPE Field Findings', *Journal of Environmental Psychology*, 27 (3), 2007, pp. 177–189

Vischer, J, *Space Meets Status: Designing Workplace Performance*, New York & Abingdon: Routledge, 2005

Vischer, J, 'Designing the work environment for worker health and productivity', *Design and Health*, 2003, pp. 85–93

Vischer, J, 'The concept of comfort in workplace performance', *Ambiente Construido*, 7 (1), Jan-Mar 2007, pp. 21–34

Vischer, J, 'Towards an environmental psychology of workspace: How people are affected by environments for work', *Architectural Science Review*, 51 (2), pp. 97–108

Libraries

Drucker, P, 'The Next Society, A survey of the Near Future', *The Economist*, 1 Nov 2001. [Accessed on 11 Mar 2010]. Available at: http://www.druckerinstitute.com/whydrucker/why_articles_nextworkforce.html

Erlich, A, and Bichard, J-A, 'The Welcoming Workplace: Designing for Ageing Knowledge Workers', *Journal of Corporate Real Estate*, 10 (4), pp. 273–285

Harrison, A, *Emerging Technology and Learning Places*, [Accessed 31 Jan 2009], Available at: http://www.degw.com/knowledge_studies.aspx

Harrison, A, and Cairns, A, 'The Changing Academic Workplace', *Effective Spaces for Working in Higher and Further Education*, DEGW UK Ltd, 2008. [Accessed on 5 Jan 2010]. Available at: http://www.exploreacademicworkplace.com/index.php/site/links_contacts/,

Harrison, A, Wheeler, P, and Whitehead, C, *The Distributed Workplace: Sustainable Work Environments*, London and New York: Spon Press, 2004

Jamieson, P, 'Positioning the University Library in the New Learning Environment', *Planning for Higher Education*, 34 (1), 2005, pp. 5–11

Locke, W, *The Changing Academic Profession in the UK: Setting the Scene*, London: Universities UK, 2007. [Accessed 17 Feb 2010]. Available at: http://oro.open.ac.uk/11843/

Pinder, J, et al, *The Case for New Academic Workspaces*, Department of Civil and Building Engineering, Loughborough University, 2009

Research Information Network, Researchers use of Academic Libraries and their Services, A report commissioned by the Research Information Network and the Consortium of Research Libraries, 2007. [Accessed 17 Jan 2010]. Available at: http://www.rin.ac.uk/our-work/using-and-accessing-information-resources/researchers-use-academic-libraries-and-their-serv

Stages
Brockett, O, Hardberger, M & Mitchell, M, *Making the Scene: A History of Stage Design and Technology in Europe and the United States*, San Antonio: Tobin Theatre Arts Fund, 2010

Keller, M, *Light Fantastic: The Art and Design of Stage Lighting*, Munich, Berlin, London & New York: Prestel Verlag, 2006

Cities
Bishop, P & Williams, L, *The Temporary City*, London & New York: Routledge, 2012

Dines, S and Cattel, V, with Gesler, W and S Curtis, S, *Public spaces, Social Relations and Well-being in East London*, Bristol: Policy Press, 2006

Goffman, E, *Behaviour in Public Places: Notes on the Social Organisation of Gatherings*, New York: The Free Press, 1963

Hornecker, E, 'Space and Place – Setting the Stage for Social Interaction', *European Conference on Computer-Supported Cooperative Work*, September 2005

Ludvigsen, M, 'Designing for Social Interaction: Physical, Co-Located Computing', *PhD thesis*, Aarhus School of Architecture, December 2006

Ludvigsen, M, 'Designing for Social Use in Public Places: A Conceptual Framework of Social Interaction', *Proceedings of the Sixth Conference on Designing Interactive Systems*, 2006, 348

Mean, M & Tims, C, *People Make Places: Growing the Public Life of Cities*, London: Demos/JRF, 2005

Teams
Hackman, R.J, *Leading Teams: Setting the Stage for Great Performances*, Boston, Massachusetts: Harvard Business School Press, 2002

Hansen, M.T, *Collaboration: How Leaders Avoid the Traps, Create Unity and Reap Big Results*, Boston, Massachusetts: Harvard Business School Press, 2009

Karau, S. J, & Williams, K. D, 'Social loafing: A meta-analytic review and theoretical integration', *Journal of Personality and Social Psychology*, 65, 1993, pp 681–706

Katzenbach, J.R, & Smith, D.K, *The Wisdom of Teams: Creating the High-Performance Organisation*, Maidenhead: McGraw-Hill Publishing Company, 1998

Mulvey, P. W, Veiga, J. F, & Elsass, P. M, 'When teammates raise a white flag', *Academy of Management Executive*, 10(1), 1996, pp. 40–49

Salas, E, Tannenbaum, S.I, Cohen, D.J, & Latham, G, eds., *Developing and Enhancing Teamwork in Organisations: Evidence Based Best Practices and Guidelines*, San Francisco : Jossey-Bass, 2013

Sundstrom, E. D, *Supporting work team effectiveness: Best management practices for fostering high performance*, San Francisco: Jossey-Bass, 1999

Image credits

© Copyright 2014 Black Dog Publishing Limited, London, UK.
All rights reserved.

No part of this publication may be reproduced, stored in a
retrieval system, or transmitted, in any form or by any means,
electronic, mechanical, photocopying, recording, or otherwise,
without prior permission of the publisher.

Designed by Amy Cooper-Wright and Matthew Boxall at
Black Dog Publishing.

Black Dog Publishing Limited
10a Acton Street, London WC1X 9NG
United Kingdom

Tel: +44 (0)20 7713 5097
Fax: +44 (0)20 7713 8682
info@blackdogonline.com
www.blackdogonline.com

British Library Cataloguing-in-Publication Data.
A CIP record for this book is available from the British Library.

ISBN 978-1-908966-78-0

Black Dog Publishing Limited, London, UK, is an environmentally
responsible company.

'Life of Work' is printed on sustainably sourced paper.

reuse recycle reduce

art design fashion
history photography
theory and things

black dog
publishing

london uk

www.blackdogonline.com